Historic England

Herefordshire

Malcolm Mason

AMBERLEY

For Theresa

First published 2019

Amberley Publishing
The Hill, Stroud, Gloucestershire, GL5 4EP
www.amberley-books.com

The publisher is grateful to the staff at Historic England
who gave their time to review this book.

All contents remain the responsibility of the publisher.

ISBN 978 1 4456 9201 2 (print)
ISBN 978 1 4456 9202 9 (ebook)

British Library Cataloguing in Publication Data.
A catalogue record for this book is available from the
British Library.

Typesetting by Aura Technology and Software
Services, India. Printed in Great Britain.

Contents

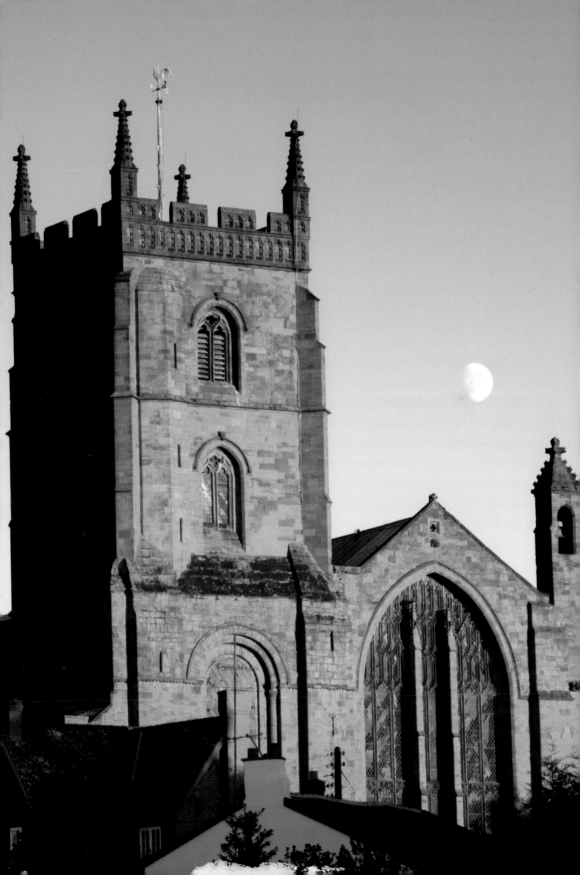

Introduction

Herefordshire is one of England's most rural counties, and is isolated in its setting. Its borders are formed by a ring of hills. In the east the ancient Precambrian rocks of the Malvern Hills form a natural barrier to the rest of England, and in the west the county washes against the edge of the Black Mountains and the border with Wales. Its centre is a saucer of rolling countryside cut by the River Wye and its tributaries.

The physical separation has been deepened by human events. In this border county English and Welsh influences have ebbed and flowed for centuries, and each has left its legacy in customs and distinctive places. Early people left their traces in burial chambers and cists. Later in the Iron Age people covered the tops of hills with more than forty forts across the county. During more settled times towns developed. With Hereford at the centre, and with the exception of Kington, all the county's market towns – Bromyard, Leominster, Ross-on-Wye and Ledbury – were important centres even in Saxon times. After the Norman Conquest, Herefordshire was firmly established as a Marcher shire, a frontier society in every sense. The Norman lords retained their own laws and kept order by building the densest concentration of castles in the kingdom. It is ironic that at the same time as this turmoil, perhaps because of it, great art flourished.

The main industry has always been agriculture – cattle and sheep, orchards and hops. The nature of farming shaped the farmyard and its buildings, and like the houses in the villages nearby they were often built of the locally abundant timber. The history of the county is preserved in these buildings: they bear testament to the periods of great wealth generated from the soil, and their preservation during periods of poverty when no one had the funds to modernise them.

Geography and history have combined in Herefordshire to produce a place of remarkably varied and distinctive appeal. Despite recent changes this is still a county on a human scale. It has a wealth of history, architecture and culture, and its one city, five small market towns and many villages continue to have diverse and very individual personalities. This collection of photographs offers an insight into this county and some of the lesser-known places and fascinating characters that make up its rich heritage.

An Ancient Landscape

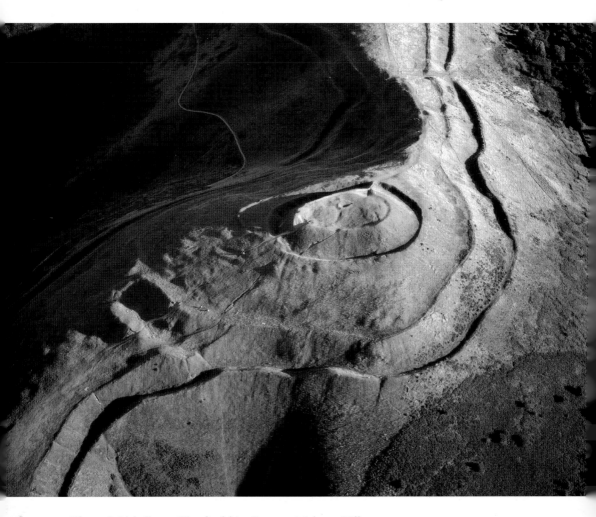

Above: British Camp, Herefordshire Beacon, Malvern Hills
The eastern boundary of the county is formed by the Malvern Hills. Three tops on the Herefordshire Beacon in the southern hills are covered by this extensive hill fort. The fort has a perimeter of over 2 km, a remarkable feat considering the ramparts were dug using picks made from antlers. The diarist John Eelyn (1620–1706) thought the view from the hill was 'one of the godliest vistas in England'. (© Historic England Archive)

Opposite above: Wynds Point and the Malvern Hills from British Camp
The pass between British Camp and Black Hill was always one of the primary points for travellers to cross the Malvern Hills. Not surprisingly an inn was established here where horses could be changed and travellers could rest. Today the much-extended building is the Malvern Hills Hotel, but in the past it has been the British Camp Hotel, Camp Inn and Peter Pocket's – the name of the landlord at the time. Beyond the hotel is 'Wynds Point', the cottage Swedish soprano Jenny Lind lived in until her death in 1887. (Historic England Archive)

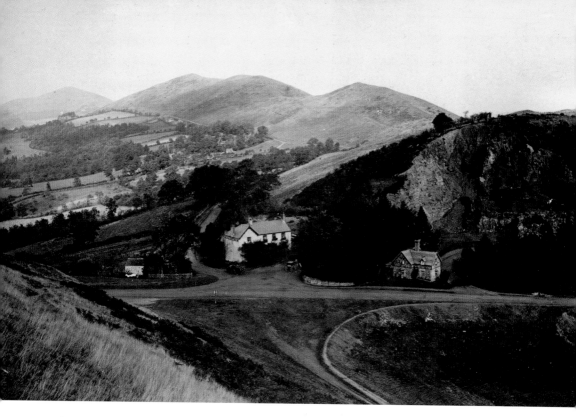

Below: Upper Colwall, Colwall
Looking north-east over Upper Wyche, a suburb of West Malvern. The Wyche Cutting itself forms a narrow pass through the crest of the Malvern Hills. This pass was once part of an Iron Age salt route – hence the name Wyche, thought to be a corruption of Hwicce, the ancient British tribe who controlled this trade. (© Historic England Archive)

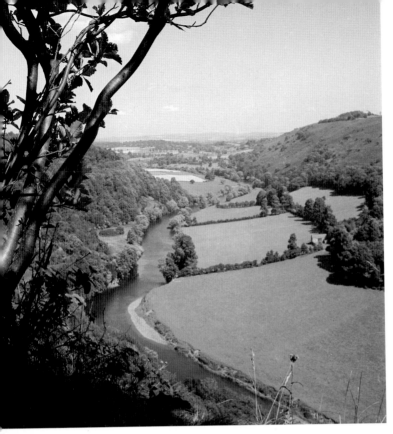

Symonds Yat, Goodrich

Much of southern Herefordshire is made up of relatively soft rocks and this has produced a gentle landscape of rolling hills and plains cut by wide river valleys. This changes dramatically at Symonds Yat where, as the ice melted after glaciation, a much-enlarged river eroded layers of sandstone and limestone into deep gorges with impressive cliffs. Before entering this area of spectacular scenery the river starts and completes a 5-mile-long horseshoe-shaped meander. (© Historic England Archive)

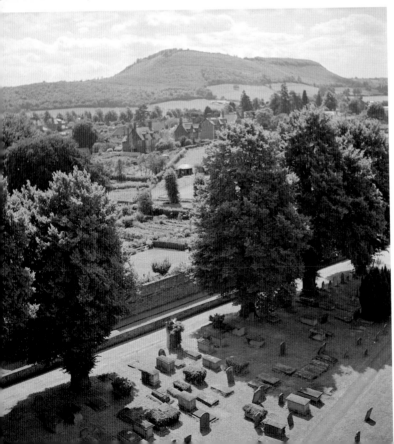

Looking towards Chase Wood

Chase Hill rises to 200 metres to the south of Ross-on-Wye and has panoramic views of the surrounding landscape. Unsurprisingly, it became the site of an important hill fort during the Iron Age, which was occupied right up to the Roman invasion. The bishops of Hereford hunted in the wood in medieval times, and in the late nineteenth and early twentieth centuries it was the setting for a rifle range and military training. (© Historic England Archive)

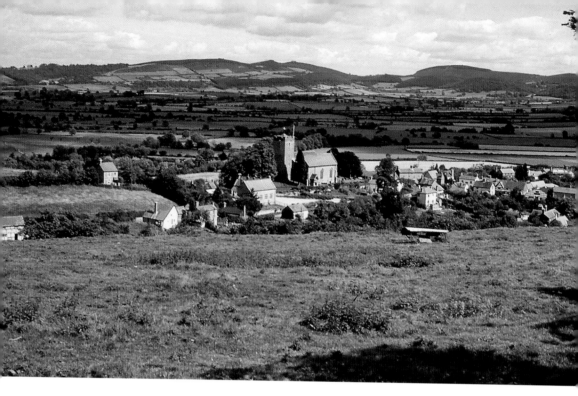

The Landscape of North Herefordshire: Wigmore and Croft Ambrey

Wigmore was one of the few boroughs in Herefordshire recorded in the Domesday Book, but the church is older and has Anglo-Saxon origins. For nearly 250 years the town was the seat of the Mortimer family, the earls of the March, and one of the largest links in a chain of strongholds along the Welsh border. Settlement on the ridge in the background has an even longer history and the hill fort on the summit of Croft Ambrey was in use from the sixth century BC.

The Centre of Herefordshire

This little-known monument was placed here by William Jay and his friends in April 1857 to mark the centre of Herefordshire. They also planted the yew trees surrounding it. The stone is not easy to find, as it stands some distance to the north of Hereford between Pipe and Lyde and Holmer, a few yards to the east of the A49 near the track leading to Hill Barn.

Above: The Landscape in Western Herefordshire around Upper Newton Farm, Kinnersley
The countryside of much of the central and western part of the county is dominated by small villages, hamlets and scattered farms linked by a network of small winding lanes. These all sit within a framework of small hedged fields, which order the landscape and maintain a rich habitat for wildlife. (Historic England Archive)

Opposite above: Offa's Dyke, near Kington
The standard view is that this earthwork was built by order of King Offa of the ancient kingdom of Mercia in the eighth century to mark the boundary between England and Wales. Recent research has suggested that parts of it might be considerably older than this, and far from stretching along the whole border from sea to sea the main Dyke was actually a much shorter structure, and the sections in western Herefordshire mark its southern limit in this area.

Opposite below: Green Lane, Dog Hill Wood, Ledbury
Herefordshire has a wealth of historic green lanes, a reminder of a time when travel relied on a network of tracks and paths linking every farm, village and town. As the more travelled tracks became paved roads, the lesser used have survived as footpaths or, as in this example from Dog Hill Wood, as unsurfaced, sunken lanes, which are all now part of the network of public rights of way across the county. (© Historic England Archive)

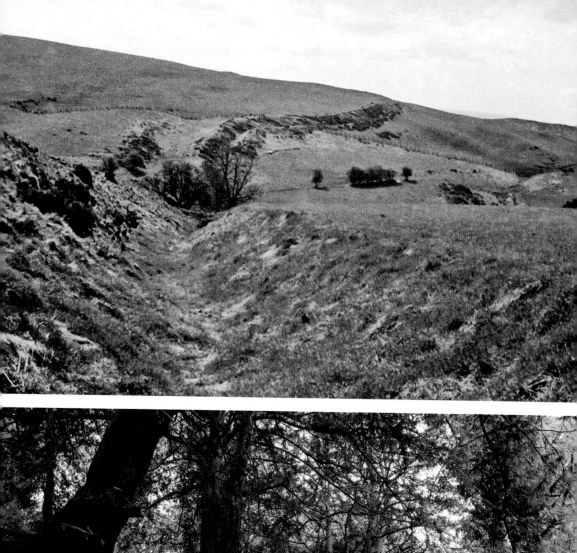
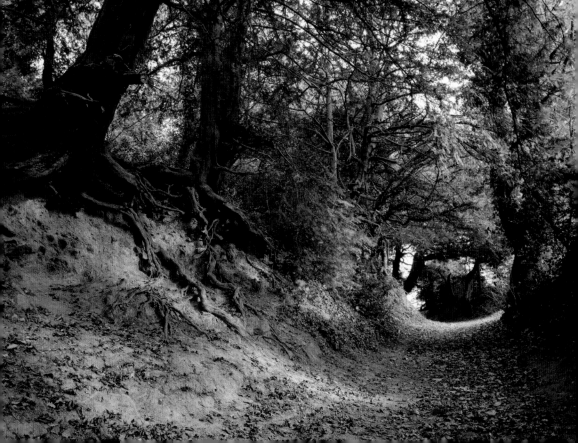

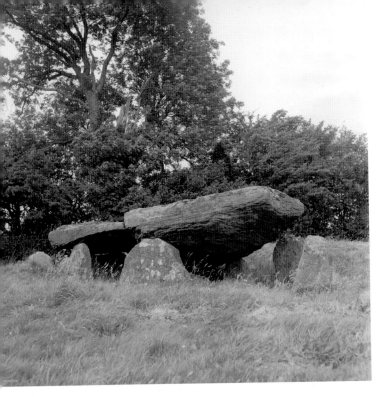

Arthur's Stone Megalithic Tomb, Dorstone
This Neolithic chambered tomb on a ridge leading to Merbach Hill is around 5,000 years old, making it one of the oldest human artefacts in the county. A slab-lined passage leads to a principal structure with a capstone estimated to weigh more than 25 tons resting on nine uprights. C. S. Lewis was apparently so moved by this site that it is said to have inspired the stone table upon which Aslan is sacrificed in *The Lion, the Witch and the Wardrobe*. (Historic England Archive)

Wordsworth's Stone, Leysters
William Wordsworth loved to visit Herefordshire. On 22 October 1845 the poet and his wife Mary were at Leysters and rested for a while on a roadside stone. The vicar of Leysters was so thrilled by these celebrated visitors that he had the initials 'WW' and 'MW' carved on what became known as the Poet's Stone. The Leominster morris men dance here on the poet's birthday in commemoration of his life and work.

A Land of Castles

Snodhill Castle from the South

In this atmospheric shot the ruins of Snodhill Castle rise form the early morning mist in the Golden Valley close to the Welsh border. Founded before 1136, the castle was one of many built by William the Conqueror's lieutenants to secure the Welsh Marches. Snodhill was refortified and rebuilt many times over the next 300 years, and much of the stone was removed to build a nearby manor house between 1649 and 1652. In many parts of Herefordshire settlements grew up near such castles, but this does not seem to have happened here. (© Historic England Archive)

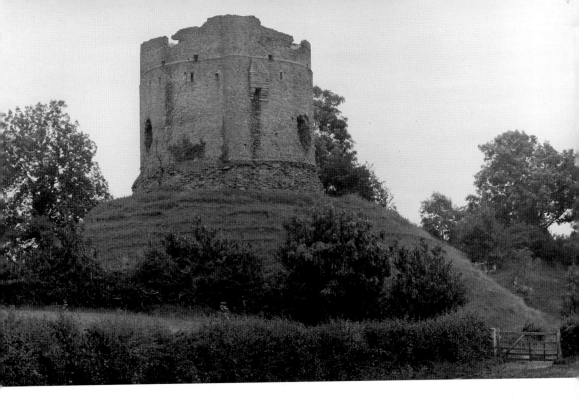

Longtown Castle

In the twelfth century one of the powerful Marcher families, the de Laceys, spent the then enormous sum of £37 improving this castle and building the keep, which is still standing today. Longtown was planned as a medieval town, but development stalled and the settlement did not expand beyond a small village. The castle site has recently been the focus of a series of very successful community archaeology projects carried out by the Longtown and District History Society. (Historic England Archive)

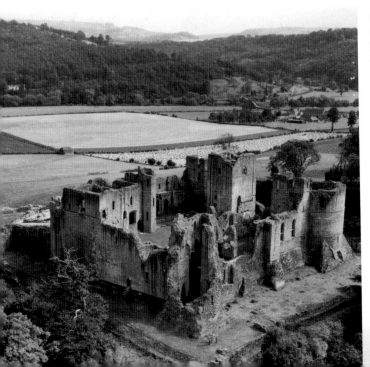

Goodrich Castle

Guarding a crossing point on the River Wye, this castle dominates the countryside between Monmouth and Ross-on-Wye. It was significantly expanded in the late thirteenth century to include the latest design of concentric walls for defence. The castle was besieged by Parliamentarians in the Civil War. The garrison held out for two months, but were eventually battered into submission and the castle 'slighted' to prevent further use. One of the cannon used in the siege, 'Roaring Meg', is on display in the courtyard of the castle – the only surviving mortar from the Civil War. (© Historic England Archive)

Right: Penyard Castle
This castle was possibly built as a hunting lodge by Aymer de Valence, who died in 1324 and was also responsible for building Goodrich Castle. A later house incorporated some of the buildings but the main part or the castle fell into ruin. The remains of a tunnel possibly leading to a blocked cellar may have given rise to the legend that there is a cave beneath the castle full of treasure, guarded by an evil bird who never sleeps. The legend also comes with an inevitable health warning: anyone opening the treasure store will be drawn into the vault and entombed. (© Historic England Archive)

Below: Croft Castle, Yarpole
The original Croft Castle was built in the eleventh century by the Croft family, although some distance from the present structure. The core of the current building is no earlier than sixteenth century. As with many castles, as the need for defence decreased it was modified and extended to become a country house. The Crofts sold the estate in 1746, but a member of the family bought it back in 1923. It is now in the care of the National Trust.

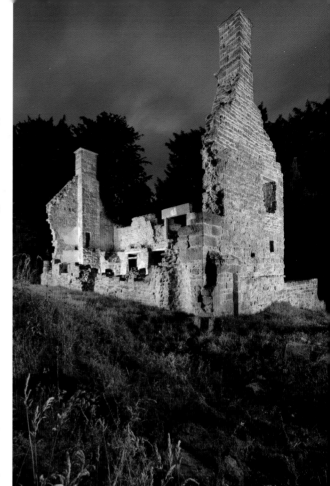

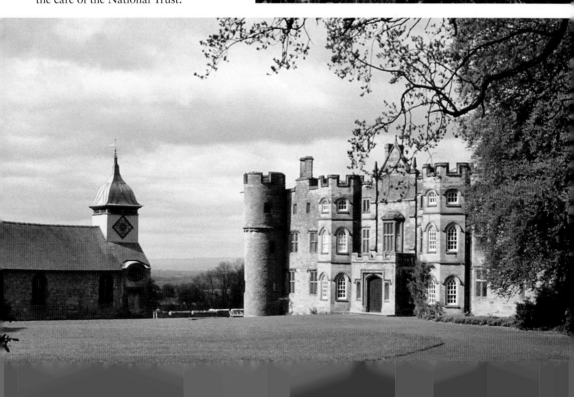

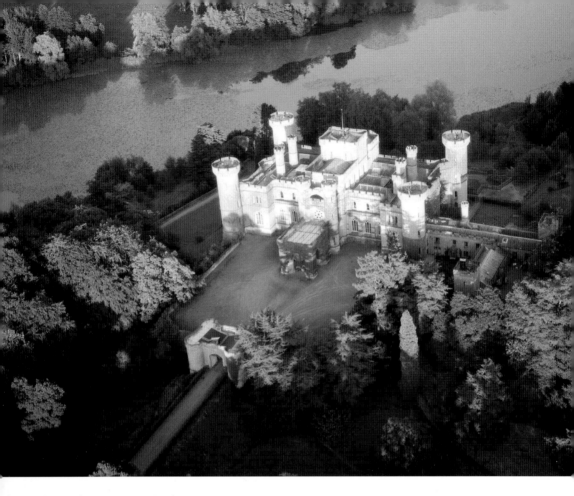

Above: Eastnor Castle
The country house at Eastnor at the foot of the Malvern Hills near Ledbury is a mock or revival castle, trying to create the impression of an Edward I-style medieval fortress guarding the Welsh borders. Built between 1811 and 1820 by Robert Smirke for the 2nd Baron Somers as his stately home, it continues to be inhabited by his descendants. By any standards, the castle is striking and has provided the backdrop for many films and television programmes. Each year the nearby deer park is the venue for the Big Chill music festival. (© Historic England Archive)

Opposite above: Downton Castle, Teme Valley
The Knight family amassed a fortune producing iron, and one of their biggest forges was at Downton on the River Teme. By the early eighteenth century the estate here extended to 4,000 hectares, and it was here between 1773 and 1778 that Richard Payne Knight built Downton Castle on an L-shaped plan with crenelated towers at the corners. Knight also laid out the landscape park. Its design was heavily influenced by his views on the wild nature of the picturesque, a subject on which he wrote extensively. (Historic England Archive)

Opposite below: The Folly, Gatley Park, Aymestrey
This house was built between 1961 and 1964 by Raymond Erith for Mrs Peggy Willis in the grounds of the Dunn family's Gatley Park estate. It is in the form of an oval, domed, three-storey tower built around a spiral staircase whose central newel post is reputed to be the trunk of one large tree. Although it commands far-reaching views and is thought to be one of the architect's best works, this listed building has been described rather unkindly as a 'windmill without sails'. (© Historic England Archive)

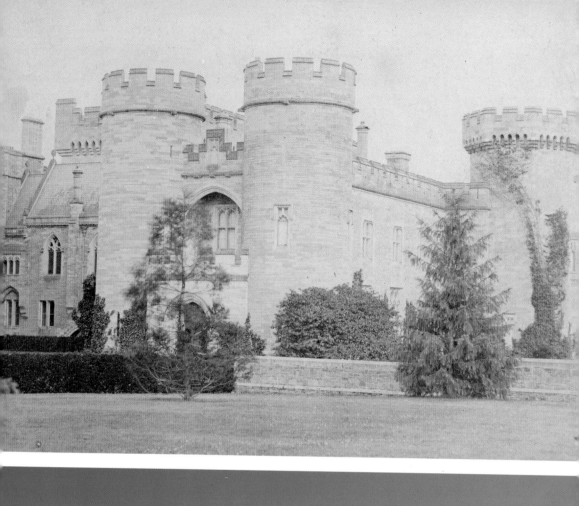

Country Houses

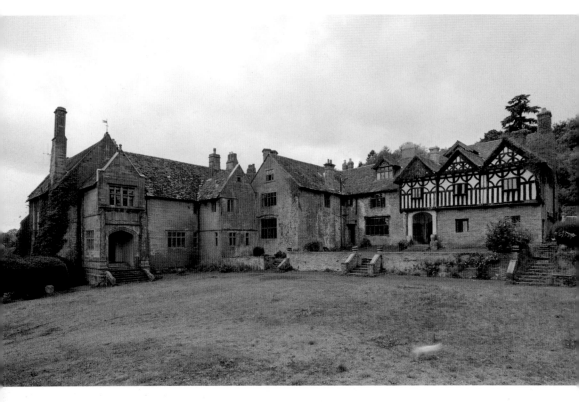

Above: Michaelchurch Court, Michaelchurch Escley
The oldest part of this building is thought to date from Norman times, with extensions added from the fifteenth through to the nineteenth centuries. It appears money was not a limitation for this building as it was not only the principal residence in the village for many years but it was also the seat of the manorial court. As with many of the old country houses 'the Court' went into decline after the Second World War. It was empty for a time, but has been restored since its sale in the 1970s. (© Crown copyright. Historic England Archive)

Opposite above: Kentchurch Court, Kentchurch
This house is considered by many to be one of the most important historic houses in England as the estate has been owned by one family – the Lucas-Scudamores – for almost 1,000 years. It is set in 10 hectares of gardens and has a remarkable collection of art including Grinling Gibbons carvings and portraits dating back to the sixteenth century. (Historic England Archive)

Opposite below: Park House, Huntington
Park House was the home of the Romilly family, Huguenots who settled in England in 1701. Esmond Romilly was born there in 1918 and went on to fight for the International Brigade in the Spanish Civil War, marry Jessica Mitford, and die in a bombing raid over Germany in the Second World War. Esmond was a nephew of Clementine Churchill, and Winston Churchill is known to have visited the house during the war. The house was demolished in 1966. (Historic England Archive)

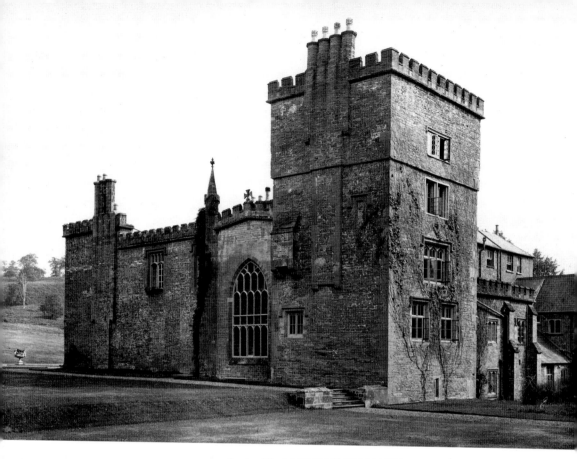

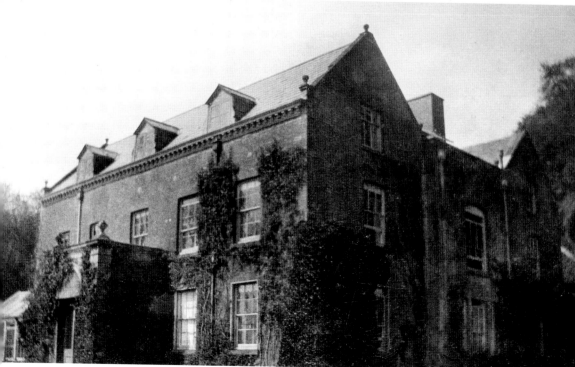

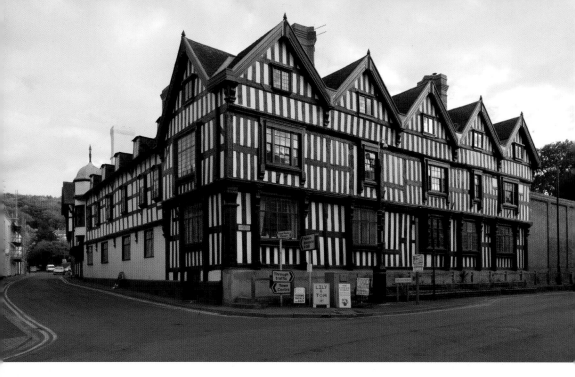

Ledbury Park (New House), Ledbury
This imposing Grade I listed sixteenth-century mansion stands in the centre of the town, and has been described as the grandest black and white house in the county. Thought to be built on the site of a former palace of a bishop of Hereford, it dominates the town, yet its grounds and its position at the junction of the High Street and Southend set it apart. (© Historic England Archive)

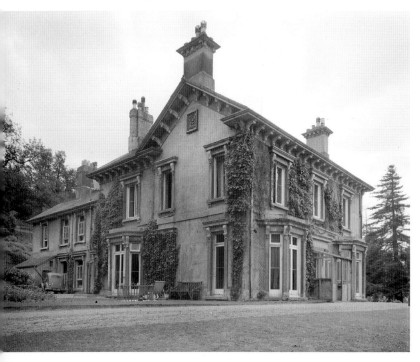

Linden Manor Hotel, Upper Colwall
Once the home of Stephen Ballard, designer of the Ledbury Viaduct, Linden Manor was a hotel when this picture was taken. Later it became a nightclub before becoming the headquarters and residential centre for Colony Holidays for Schoolchildren in 1969. The organisation stopped providing holidays at Linden in 1985 and the building is now a residential home. (Historic England Archive)

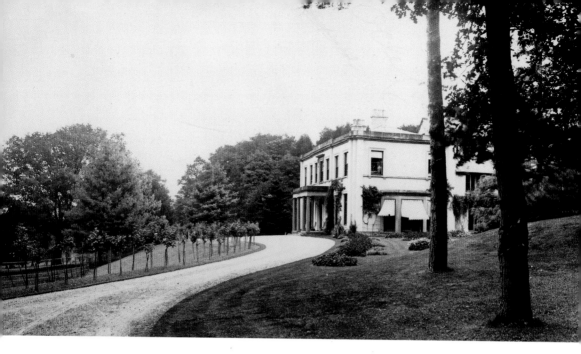

Above: Ocle Court, Ocle Pychard
At around the time this picture was taken Ocle Court was owned by Lieutenant Colonel Heywood. His wife founded the St George Home for Orphan Girls. The home took in a limited number of children and trained them in domestic skills, preparing them for a working life in service. (Historic England Archive)

Below: Shobdon Court Garden, Shobdon Park
Only the service wing and stable block remain of the grand eighteenth-century house that once stood here. The gardens were a particular feature, with formal gardens near the house leading to a centrepiece lawn with specimen trees, and descending to an arboretum and two pools. The garden also features arches from the interior of the nearby St John's Church, removed in the eighteenth century to the grounds of the court. The Grade I listed St John's, built in the Rococo style, is one of the region's finest eighteenth-century churches. (Historic England Archive)

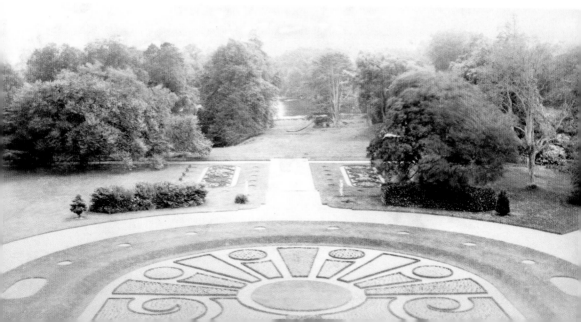

Agriculture and Country Life

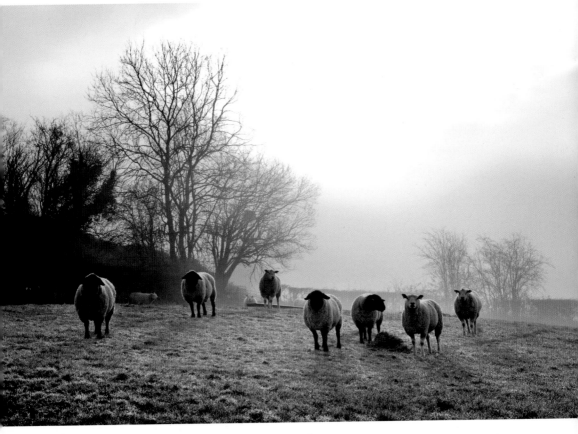

Above: Sheep in a Frosty Field near Snodhill Castle
'I know of no land more full of bounty than this red land, so good for corn and hops and roses. I am glad to have lived in a county where nearly every one lived on and by the land, singing as they carried the harvest home, and taking such pride in the horses, and in the great cattle, and in the cider trees. It will be a happy day for England when she realises that those things and the men who care for them are the real wealth of the land: the beauty and bounty of the earth being the shadow of heaven.' John Masefield, Poet Laureate, accepting the Freedom of Hereford, October 1930. (© Historic England Archive)

Opposite above: Ryelands Sheep
Sheep were a cornerstone of the county's farming economy. This goes back at least seven centuries when the monks of Leominster bred the Ryeland, one of the oldest English breeds. Ryelands were valued for their docility, high fertility and ability to do well on poorer pastures. Their wool was reputed to be the finest in England. Known as 'Lemster Ore', it provided the wealth to build many of the fine houses and churches featured in this book.

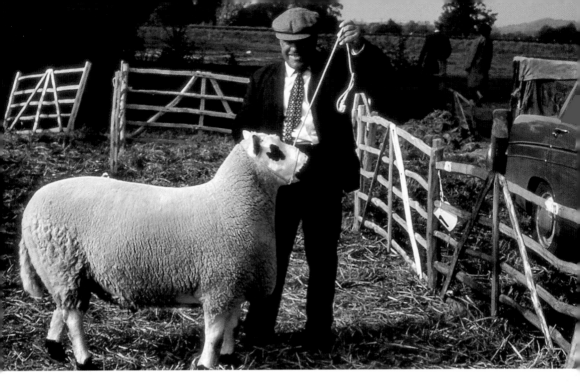

Below: Hereford Cattle at Leominster Show

The other foundation of farming was cattle, and it is not surprising that Hereford cattle continue to feature prominently in agricultural shows, not only here, but in the fifty or more countries to which they have been exported. First bred at the end of the eighteenth century, the Hereford Herd Book Society in East Street, Hereford, is still the world centre for recording every aspect of the pedigree.

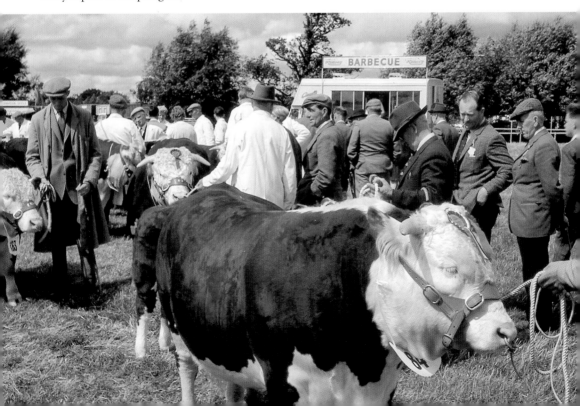

The White House Barn and Cider House, Marden
This is a reminder of a time when every farm in the county would have produced cider to be drunk by their labour force. It was even paid to workers as part of their wages and they could be given up to 6 pints a day. At especially busy times during haymaking and harvest this could rise to as much as 20 pints! After years of decline farmhouse production of cider is now rising to meet the increasing demand for artisan speciality drinks. (© Crown copyright. Historic England Archive)

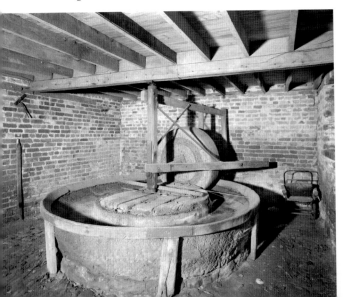

The Apple Mill at Haywood Lodge, Haywood
An apple mill consisted of a large stone wheel rotating around a circular stone trough. The wheel was powered by a small horse harnessed to a cross-beam endlessly walking round the mill. Cider apples were placed in the trough and crushed by the rotating wheel, and the resulting pulp was then loaded between hessian sheets in a screw press to extract the juice. The full story of this important industry is told in the Cider Museum in Hereford. (© Crown copyright. Historic England Archive)

Hopyard near Leominster
As with cider orchards, there were few Herefordshire farms in the eighteenth century without a hopyard. Today the commercial growing of hops is mainly restricted to the eastern half of the county. The hop-growing year starts with the 'stringing' of the permanent structure of poles and wires in March, although some farmers use the winter to complete the job. Workers use bales of natural coir string to create the framework for the hops to climb between permanent pegs in the ground and the wirework up to 6 metres off the ground.

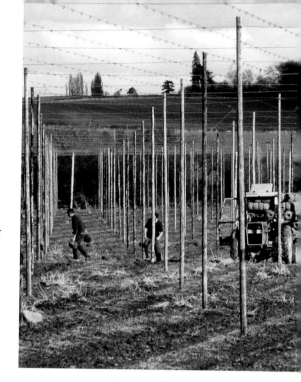

Hop Picking near Leominster
For many Herefordshire families up to the 1970s hop picking in the autumn was an opportunity to earn some extra money. Whole families would travel out to the local hopyards and spend days picking, collecting hops and stripping them off the bines into a crib. Periodically the 'busheller' would come round and measure the hops in a bushel basket and record how many had been picked. Travelling families would also work at the hopyards, staying on the farm before moving on to the next seasonal job. A number of hop pickers in Herefordshire came out from the Black Country.

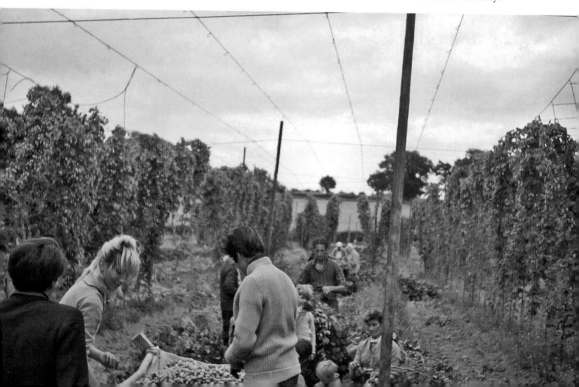

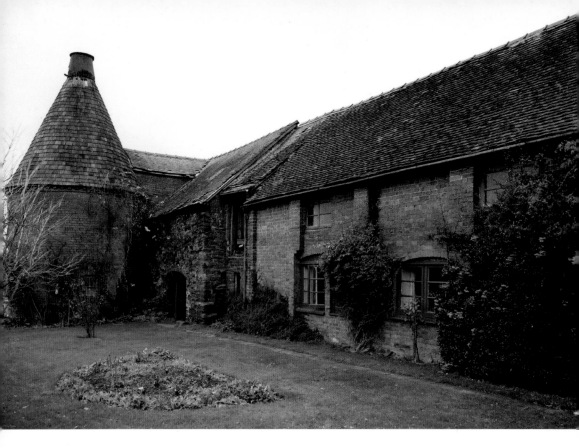

Hop-drying House at Ivington Park Farm, Ivington

Larger farms had specific buildings to dry the hops before they were sent to the brewery, as at Ivington – strictly speaking they should not be called 'oast houses' here, nor are the fields 'hop gardens'. These are found in Kent and Sussex but in Herefordshire they were usually called hop kilns and hopyards. The round kiln is unusual, and generally the square form was more popular in the county. Farmers were paid by the quality of the crop and drying played a vital role in this. Originally the drying would have been aided by a coal-powered furnace, but today hop kilns are more likely to be powered by oil or gas. (Historic England Archive)

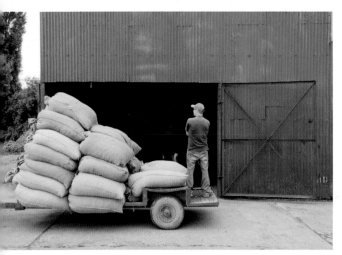

Hop Sacks at Old Court Farm, Bosbury

In the 1950s and 1960s the picking of hops became more mechanised. Farmers no longer needed a large workforce for the harvest, and instead the complete 3-metre-long hop bines could be cut in the field and brought to the farm for processing in a Bruff hop picker – a machine developed in neighbouring Worcestershire. In the picture a worker is loading sacks of hops from the farm's Bruff machine. (© Historic England Archive)

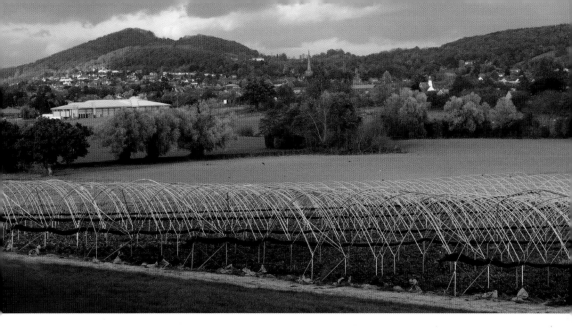

Above: Farming Landscape near Ledbury
Looking towards the Malvern Hills, the area round Ledbury, and Herefordshire in general, has seen a growth in the use of polytunnels in recent years. These have aroused fierce debate. While farmers argue that this method of farming is vital to extend the growing season and increase yields, countryside campaigners object to the visual impact of these developments and the extra traffic they generate. (© Historic England Archive)

Below: The Longhouse at Pen-y-Park, Michaelchurch Escley
One of the earliest systems of agriculture in the county housed people and beasts together under the same roof in a longhouse. A rare survivor of this system in Herefordshire is Pen-y-Park, which, before it was abandoned, appears to have been an original longhouse with the residential section on the left and the cow house on the right. The two-storey part of the house is a later addition. Pen-y-Park means 'top or head of the park', and the farmstead was probably on parkland associated with Snodhill Castle. (© Historic England Archive)

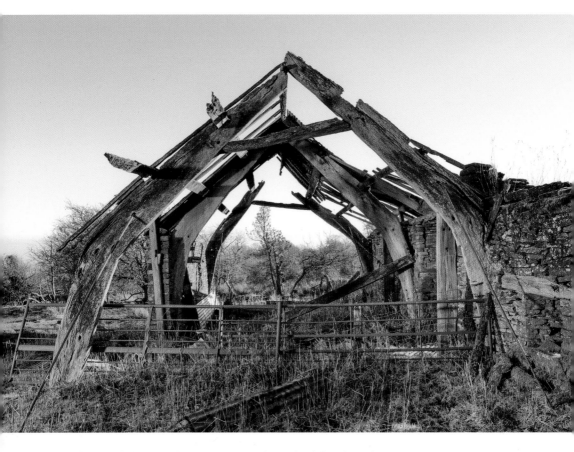

Above: Derelict Cruck Barn, Pen-y-Park, Michaelchurch Escley
The farmyard of Pen-y-Park houses the remains of an old cruck-framed barn, perhaps built between around 1500 and 1600. Crucks are an early form of construction made by splitting large curved timbers and fitting the halves together to form a series of A-frames. Although the farm and cruck barn were intact when surveyed by the Royal Commission in 1932, only three of the five frames in the barn survive today. This may be one of the tithe barns of the parish, buildings where the the owner of the tithe stored the crop they were given (one-tenth of a farmer's produce) by tithe payers. (© Historic England Archive)

Opposite above: Upper Lye Farmhouse, Aymestrey
Upper Lye is a nice example of how construction techniques developed over time. The central portion of the wing to the left of the picture was built with crucks in the fifteenth century to create a single open hall. This is adjoined by a later two-storey wing of timber framing built in the seventeenth century, itself a remodelling of an earlier cruck building. (© Crown copyright. Historic England Archive)

Opposite below: Lower Buckland Farm, Docklow and Hampton Wafer
Lower Buckland is typical of the many farmhouses built across the county in the early seventeenth century. The main building is of box framing – heavy timbers, usually oak, jointed together. The panels between the frames would have been infilled by wattle and daub, although this was often later replaced by brick. The chimney is also a later addition. (© Crown copyright. Historic England Archive)

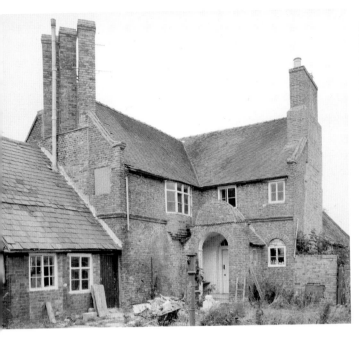

Bleathwood Manor and Barns, Little Hereford
Many grander houses also served as the focus of a farm. Bleathwood sits in an oddly shaped finger of the parish of Little Hereford almost completely surrounded by the neighbouring counties of Worcestershire and Shropshire. The manor house was built in 1582 by the Dansey family, who held it until 1837. The house was seriously damaged by fire during restoration in 2008. (© Crown copyright. Historic England Archive)

Foxhunters in Front of Aramstone, Kings Caple
Hunting foxes with hounds was formalised in England in the sixteenth century, and the social rituals and etiquette associated with a hunt became an important part of the tradition. Hunts would often meet at large houses for the stirrup cup before setting out. Here they are at Aramstone House, which was rebuilt in around 1730 and demolished in 1957, although some of the garden features survive. (Historic England Archive)

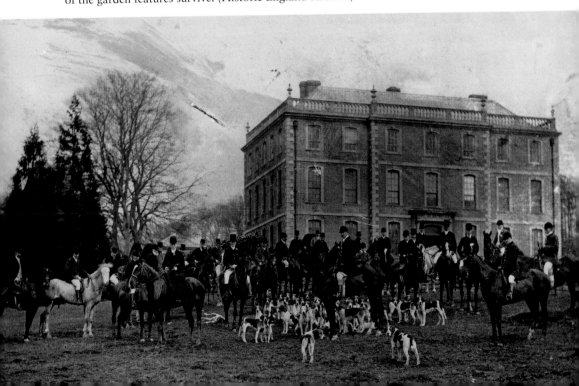

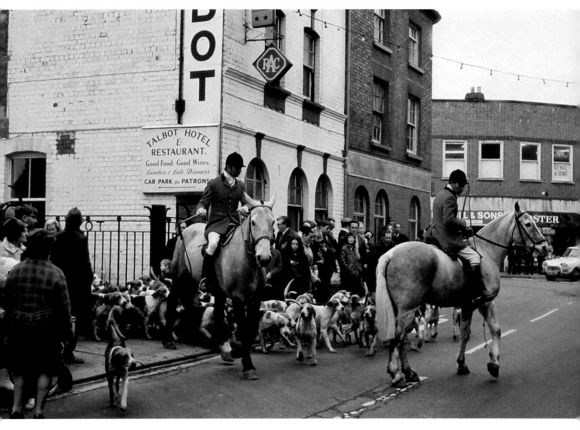

Hunt Leaving the Talbot Hotel, Leominster
The hunt set off for their traditional Boxing Day meet having taken the stirrup cup at the Talbot Hotel in the centre of Leominster.

Morris Dancers, 1961
Another English tradition, morris dancing can be traced back nearly 600 years. It almost died out in the nineteenth century, but in the last 100 years or so it has revived and is now thriving, and Herefordshire can boast a number of men's and women's sides.

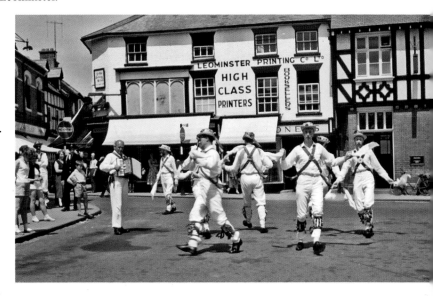

Village Life

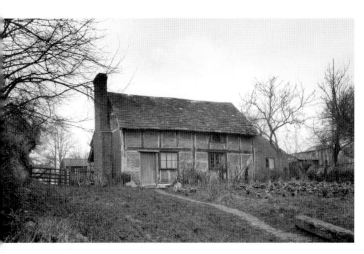

Old Smithy Cottage, Mansell Lacy
Until the last century every village had their smiths and farriers to shoe horses and make and repair everything from door hinges to agricultural machinery. Quite a few graveyards in the county have stones with inscriptions and epitaphs to smiths, including this one from Eardisley: 'My sledge and hammer lie declined, My bellows have quite lost their wind ... My coal is spent, my iron is gone, My nails are drove, my work is done.' (Historic England Archive)

Clodock Watermill, Longtown
Most villages in Herefordshire with access to a small stream had a mill to grind their corn. The Black Mountains form the backdrop to this mill on the River Monnow near Clodock. Also known as Lower Mill, it fell into disuse in 1952 when it became uneconomic to mill on such a small scale. The former miller continued to occupy the adjoining mill house into the 1980s, and as a result much of the machinery remained in place after its closure. Following restoration the mill has now been returned to working order. (Historic England Archive)

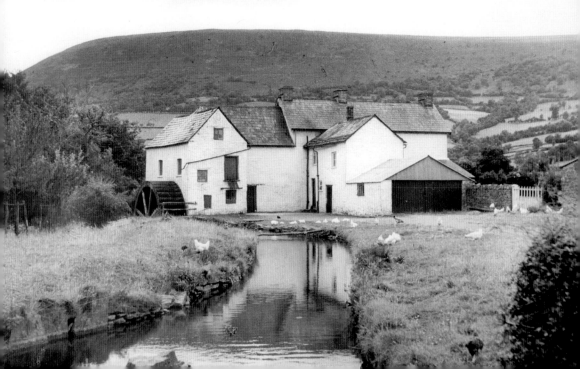

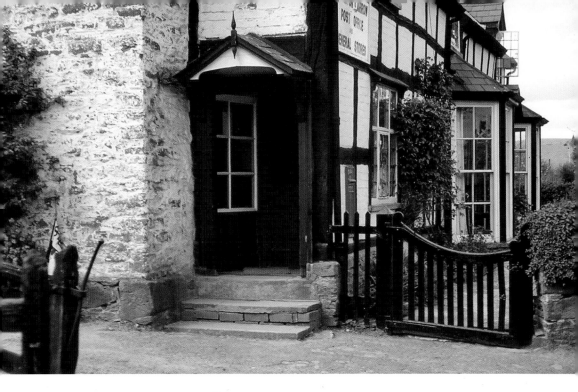

Above: Staunton on Arrow Post Office
This is a typical example of the buildings that once doubled as houses, small shops and post offices in most of the villages in the county. Smaller villages could not sustain these services and, as in this instance, many have closed. This building is now a private house.

Below: Much Marcle Garage
This building began its life as a First World War aircraft hangar in Aston Down, Gloucestershire. When the station was sold off after the war this hangar was purchased by the Westons Cider Company and rebuilt here in around 1926 as a garage and service depot for its vehicle fleet. The garage is still in use, and due to its historical significance was listed in 2012. (© Historic England Archive)

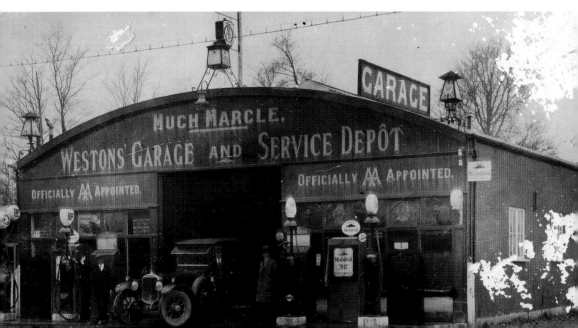

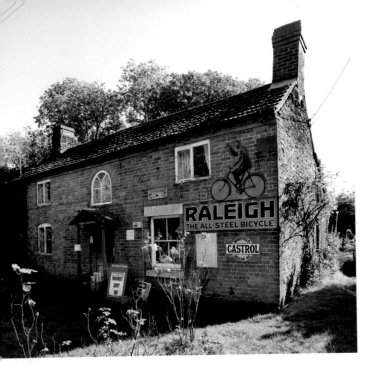

'Glendore', the Former Garage and Village Shop, Turnastone, Vowchurch
This is believed to be the oldest surviving petrol station in England. James Charles Wilding began his business here in 1919, and in 1922 he was granted the second licence to supply petrol in the country. It is still owned by the same family, and remains open. (© Historic England Archive)

Interior of the Village Shop
As well as serving fuel the former garage also has a small front room serving as a village shop selling sweets, newspapers and motoring supplies, a quieter trade than in the 1930s when the garage supplied petrol to Randolph Trafford, the owner of Michaelchurch Court and the first person to own an aeroplane in the county. When he landed his Gypsy Moth in a nearby field the 28 gallons needed to fill the tanks were carried across in tins, at a cost of just over £2 – at the time much more than a farmworker would earn in a week. (© Historic England Archive)

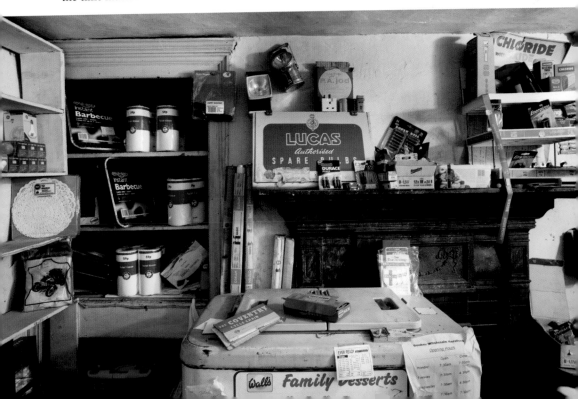

Above: Pembridge High Street

Pembridge is well known as one of the 'Black and White' villages. Most of the timber-framed houses lining the main street date from the fifteenth and sixteenth centuries when the town's proximity to the Welsh border made it an ideal location for traders to meet and carry out business between the countries in safety. At its height Pembridge had a population of over 2,000, but the town declined as security increased across the border.

Below: Pembridge Market Hall

Pembridge was first granted a charter for a market and two fairs in 1239. The Market Hall was built in the early sixteenth century in the centre of the village. The hall has an open construction in which eight oak posts support a tiled roof. One of the posts stands on the original medieval stone market cross base.

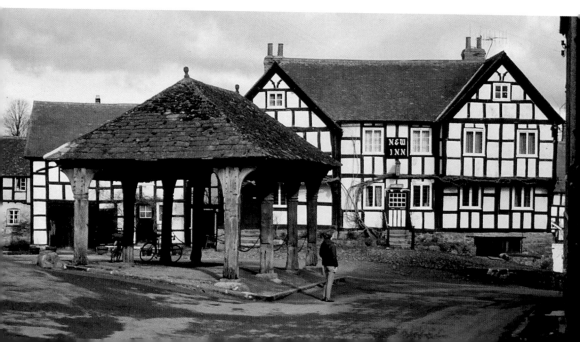

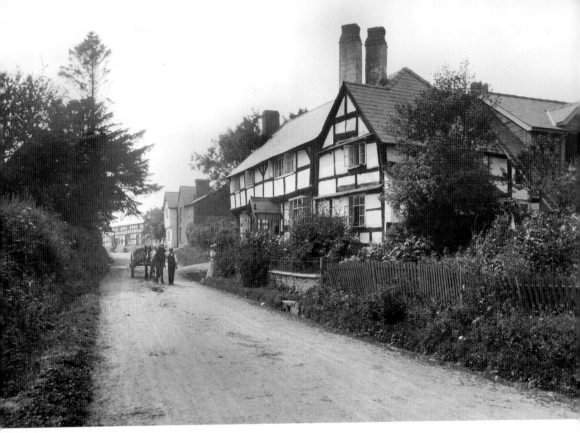

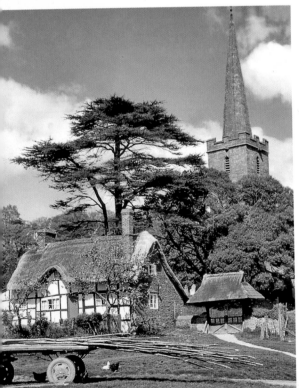

Above: East Street, Pembridge
A man stands beside a horse-drawn cart with an elegantly dressed woman standing in the front garden of Oak House on the Kington–Leominster road in the early twentieth century. The main part of Oak House has been tree-ring dated to 1551. (Historic England Archive)

Left: Stretton Grandison
The picturesque hamlet of Stretton Grandison is steeped in history. A Roman cemetery has been found nearby, and there is evidence of even earlier occupation in pieces of 6,000-year-old Neolithic wood found preserved on waterlogged soil. The church dedicated to St Lawrence has surviving fourteenth-century wall paintings, and is out of scale with the hamlet, suggesting that in the medieval period the settlement supported a bigger population.

Broad Street, Weobley
Looking north along Broad Street, with the tower of St Peter and St Paul's Church visible at the far end. The building on the left still displays the open windows, revealing its original function as a shop. These features were removed when the house was renovated for residential use. The space beyond the house was originally an open marketplace, onto which buildings later encroached: on the right of the picture this just involved building out onto the road, but on the left an entire island of shops filled the central area. The latter were destroyed by fire in 1943 and the site left as an open space. (Historic England Archive)

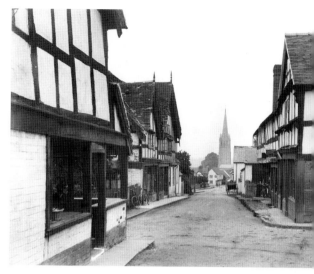

Church and Broad Street, Weobley
In this much-photographed view of Broad Street the Red Lion Hotel is visible with the tower of St Peter and St Paul's Church beyond. The story of Weobley is one of slow decline up to the nineteenth century, which may have prompted the epithet 'Poor Weobley, proud people, low church, high steeple'. Since then the town has recovered and expanded dramatically in recent years. Despite these changes the town has preserved its historic core, and it was recently declared Britain's eighth most desirable village by a national estate agent. (Historic England Archive)

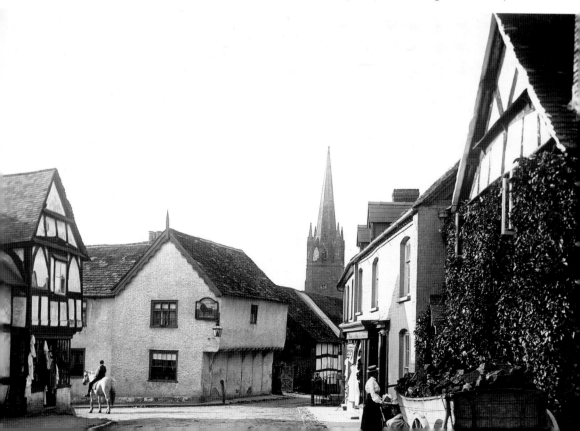

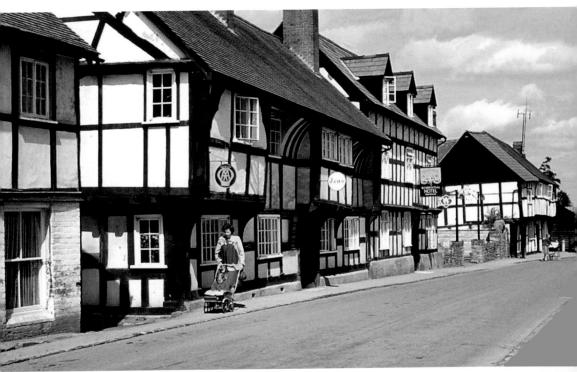

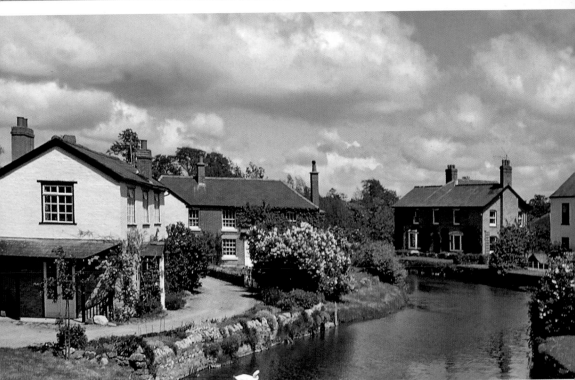

Above: The Old Grammar School, Eardisland
The school in Eardisland was built some time after a William Whittington left a bequest for its establishment in 1607. In time the school would be incorporated into the national school system and later the building was bought by a local landowner and made into a public reading room. A feature of the house is a whipping post attached to the gable end. It's not known whether this was for unruly school pupils or more general miscreants.

Opposite above: The Unicorn, Weobley
The Unicorn pub was built in the seventeenth century and once made cider from its own orchard; the story is that apple pickers were paid with tokens that could only be spent in the pub. Charles I came to Weobley after the Battle of Naseby in 1645 and stayed at what was then an inn called the Unicorn, but it was not this house. The king stayed at another Unicorn on the corner of High Street and Hereford Street, afterwards renamed The Throne in honour of the visit.

Opposite below: Eardisland and the River Arrow
Eardisland was described by Nikolaus Pevsner as 'an uncommonly pretty village'. Its charm is a happy coincidence of its situation on the River Arrow and its former poverty, which for centuries curbed the redevelopment seen elsewhere. Today its inhabitants value this legacy and have worked to restore buildings and preserve its unspoilt charm.

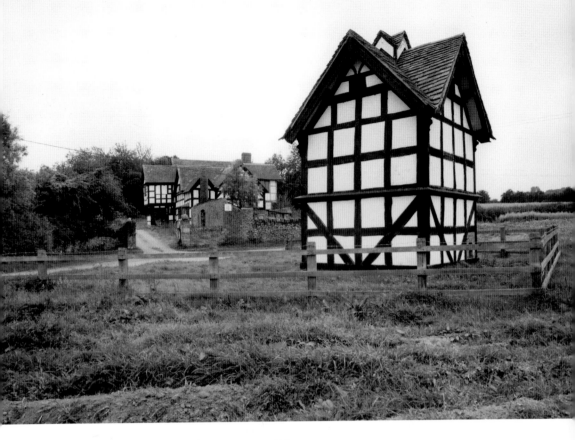

Above: The Dovecote, Luntley Court, near Dilwyn
Contrary to popular belief dovecotes did not provide meat for the winter months, but were built to provide a luxurious supplement to the wealthy people's diet for the rest of the year. Indeed, until 1619 the building of dovecotes was the prerogative of the lord of the manor. The dovecote at Luntley has been dated to 1673, and is an outstanding example of the type in a perfect setting. (© Crown copyright. Historic England Archive)

Opposite above: The Spitfire Inn, Upper Hill
The pub continues to be at the heart of many villages, but they have closed in many smaller hamlets. This was the fate of this pub in Upper Hill near Leominster. Originally The Red Lion, it became The Spitfire, and for a time had a real aeroplane, manufactured just at the end of the war, on display outside. The pub was taken over by the Sheppard family and a surplus store developed on the site. The pub closed in 1975, and the Spitfire is now believed to be owned by a collector in Belgium.

Opposite below: Timber-framed Houses, Luston
Although this picture is over 100 years old, the scene it depicts is virtually unchanged today. Luston was once the property of the Benedictine monks at Leominster although, ironically, it does not have a church despite having a sizable population. The village has a dark episode in its history. In 1645 Sir William Croft led the men of Luston on behalf of the Royalists in a battle at Stokesay Castle. The Royalists were defeated, and the Luston men deserted their lord, who was killed. (Historic England Archive)

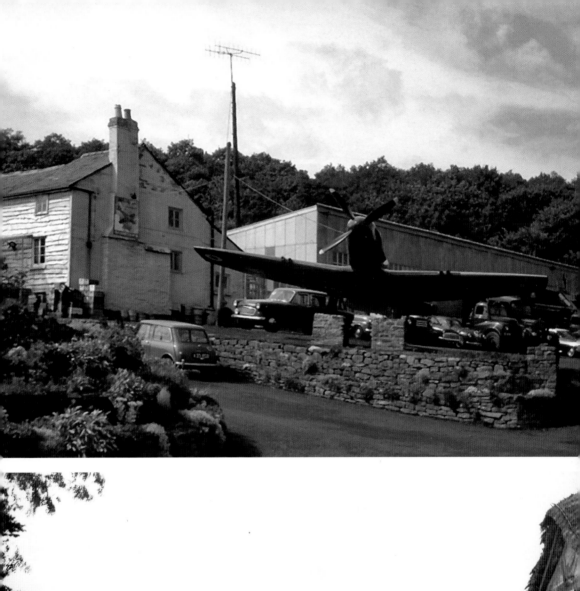
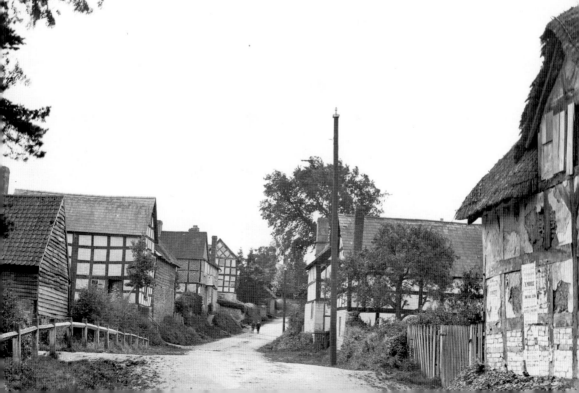

Churches in the Landscape

Above: St Peter and St Paul's Priory Church, Leominster
A building with a history as a religious site dating back to at least AD 660, the precinct of the Anglo-Saxon church can still be seen in the layout of the town. Today the impressive church incorporates parts of the Benedictine priory dedicated here in 1130. (© Historic England Archive)

Opposite above: St Weonard's Church, St Weonards
Dating back to at least 1155, St Weonard's Church is dedicated to a Celtic saint. It lies within the south-western corner of Herefordshire in the area known as Archenfield, or Ergyng. Adjoining the modern border with Wales, this was once a semi-autonomous region and retained the Welsh language and many of its own customs until the early nineteenth century. (Historic England Archive)

South Door, St Mary and St David's Church, Kilpeck Also in Archenfield and built at around the same time as Hereford Cathedral, Kilpeck represents one of the most ambitious churches of its day, appropriate for the status of this prosperous and strategically important area. Decorated with lavish sculptures, the carvings are attributed to the 'Herefordshire School' of stonemasons, who were responsible for decorating many county churches in the twelfth century. (Historic England Archive)

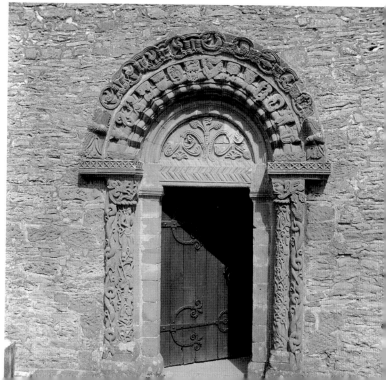

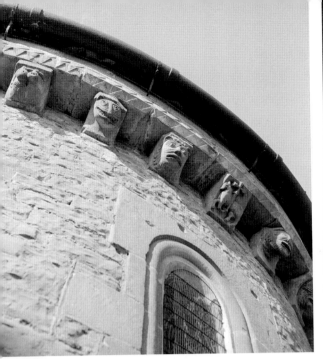

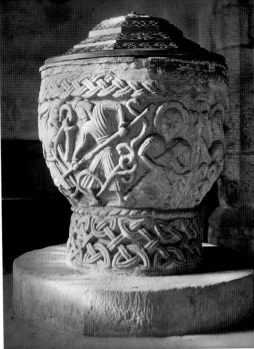

Above left: Carved Figures on Corbels, St Mary and St David's Church, Kilpeck
The eighty-five corbels surrounding the eaves of the nave, chancel and apse of this church are astonishing. The elaborate carvings represent a unique mix of Christian, Celtic, Scandinavian, Anglo-Saxon and pagan imagery in a riotous depiction of dragons, beasts, monsters and people representing all aspects of human and spiritual existence. (Historic England Archive)

Above right: The Font, St Mary Magdalene Church, Eardisley
Another product of the Herefordshire School, the Eardisley Font uniquely depicts the Harrowing of Hell – Christ's descent into Hell following his crucifixion to rescue fallen humanity. The font also depicts God the Father, the Holy Spirit in the form of a dove, a watchful lion and two fighting knights, scenes that have layers of spiritual, oral and literary meaning. (Historic England Archive)

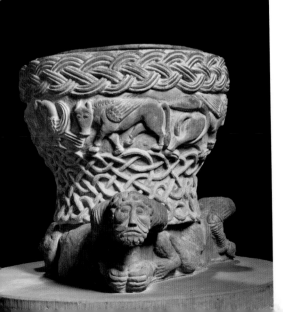

The Font at St Michael and All Angels Church, Castle Frome
Here the Herefordshire carvers depict the four Evangelists and the baptism of Christ. Niklaus Pevsner called this font 'one of the masterworks of Romanesque sculpture in England', and added 'it would arrest attention in any country'. (© Historic England Archive)

St Andrew's Church, Pixley
Hidden away behind a farmyard at Pixley Court, this tiny church is a delightful example of thirteenth-century Early English architecture. Despite being restored in the nineteenth century as many county churches were, it is a glimpse into history consisting as it does of just a chancel and a nave separated by a substantial medieval oak screen. The porch has been tree-ring dated to 1467, and the church has floor tiles attributed to William Morris. (© Historic England Archive)

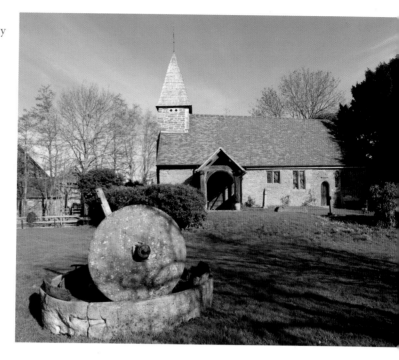

St Mary's Church, Donnington
Another rather isolated church, and as with many Herefordshire churches, St Mary's was built in the medieval period and restored and extended in the mid-1800s when the north vestry was added. The timber bell turret was added later. (© Historic England Archive)

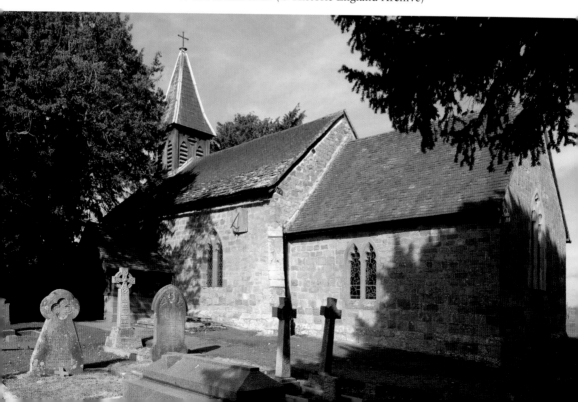

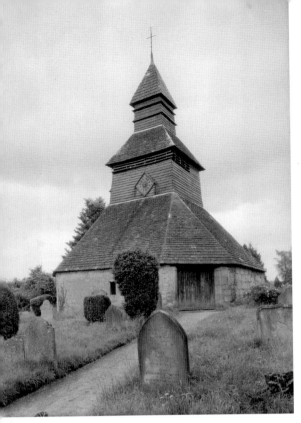

Detached Belfry at St Mary's Church, Pembridge

The detached bell tower at Pembridge was built in the early thirteenth century, and is one of the earliest surviving in the country. All but the base of the tower is timber framed. It has been rebuilt and remodelled many times, and tree-ring dating has shown the ambulatory surrounding the lower part of the structure was added in 1471. The last major change was in 1668/9, as established by dendrochronology. These towers are thought to have been used as a safe haven for the parishioners in times of crisis, and there are holes in the door here which are said to have been made by shot. (Historic England Archive)

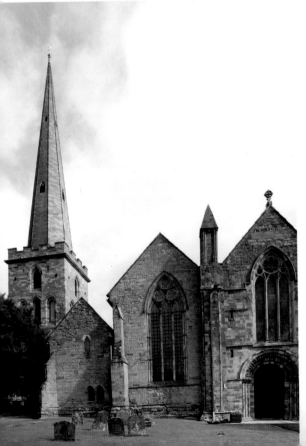

Detached Bell Tower, St Michael and All Angels, Ledbury

Described as one of the finest churches in the county, St Michael and All Angels also has a detached bell tower. The church retains much of its Norman fabric, and later work has added rich architectural details. There are clues to the defensive purpose of the bell tower in the narrow lancet windows and walls that are almost 3 metres thick. The tower was restored in the Victorian period. (© Historic England Archive)

Right: Christ Church, Llangrove,
Llangarron
Dedicated in 1856, from the outside
this appears to be a simple Victorian
building, but inside it is has none of
the over-decoration typical of that
period. It was the first complete church
designed by Sir George Frederick
Bodley, a pupil of Sir Gilbert Scott.
Bodley looked back to the simplicity
of the Early English Gothic style in his
buildings and provided the inspiration
to a style of design that later became
the Arts and Crafts movement.
(Historic England Archive)

Below: All Saints Church
Brockhampton
All Saints was designed and built by the
influential architect William Lethaby.
Completed in 1902, it is medieval in
concept but original in design and use
of materials. It is widely recognised as
one of the most important Arts and
Crafts buildings of the early twentieth
century, and has been described as one
of the most impressive and convincing
churches of its date in any country.
(Historic England Archive)

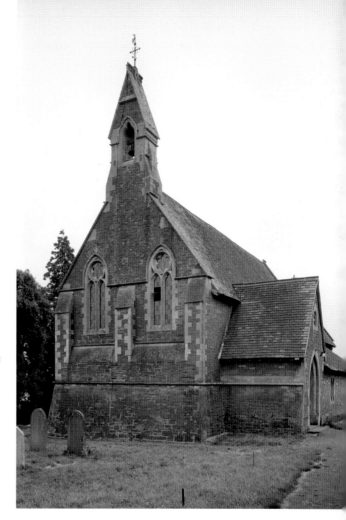

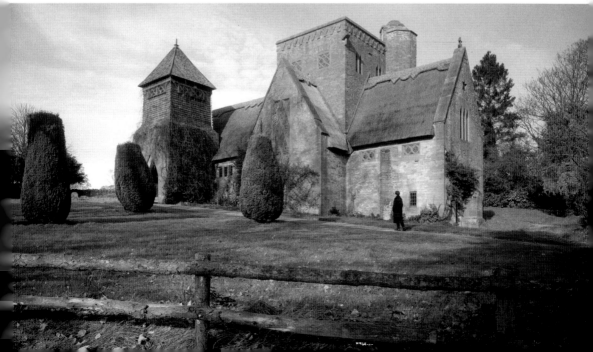

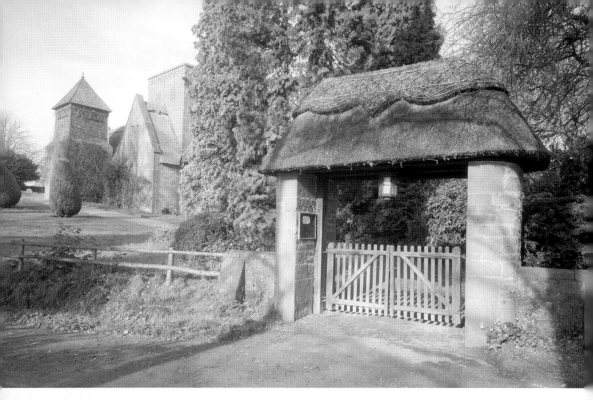

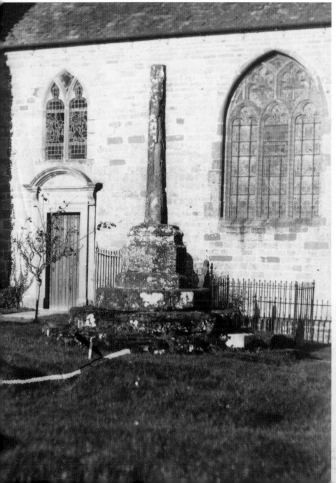

Above: The Lych Gate, All Saints
Church Brockhampton
This type of gateway with a roof
can be seen in many of the county's
churches. In Old English 'lych' means
'a corpse', and it was here the dead
were carried to await burial and where
the clergy met the funeral party to
conduct the first part of the service.
Although they have not been used
for this purpose for some time, many
modern churches, including All Saints,
adopt this traditional design.
(Historic England Archive)

Left: Churchyard Cross,
St Bartholomew's Church, Much Marcle
Medieval symbolic church crosses
erected between the tenth and sixteenth
centuries are found throughout Britain,
but many of these were removed in the
sixteenth and seventeenth centuries.
This example from Much Marcle is
a rare example as it is believed to
be in its original position. It has an
octagonal stepped base supporting
a broken shaft. Originally the shaft
would have been surmounted by
a cross. (Historic England Archive)

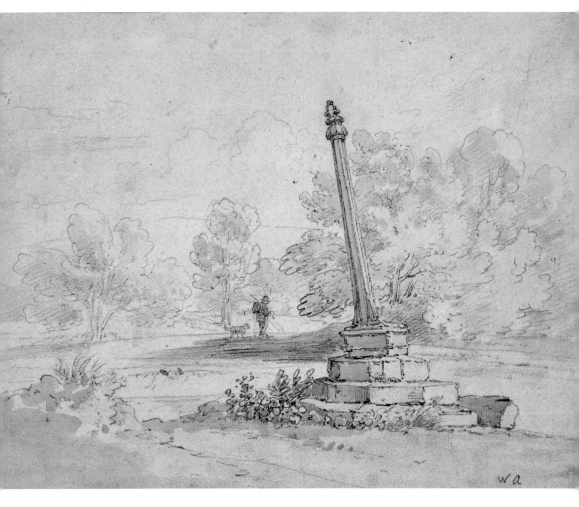

Goodrich Cross, Goodrich

Goodrich was a scattered settlement and therefore a crossroads was an important meeting place. This early watercolour painting shows a man and dog walking past the ancient cross that stood by the roadside at Goodrich Cross – a junction on the ancient Ross–Monmouth road – marked today by a cottage called Y Crwys (The Cross). Standing crosses such as this became places where people would gather for markets, preaching, proclamations and even public punishments. (Historic England Archive)

Punishment and Welfare

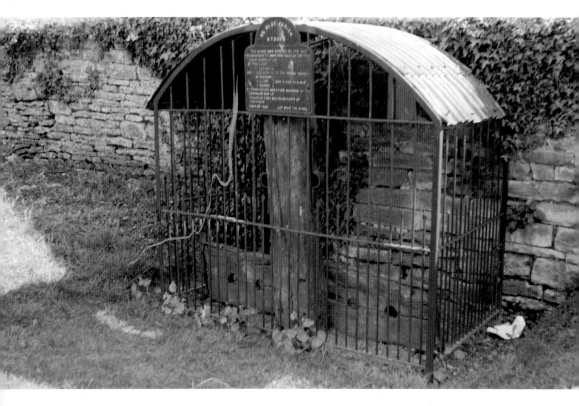

Above: The Stocks, Fownhope
Stocks were erected in most villages from the fourteenth century as a method of punishment for menial offences. The stocks in Fownhope are close to the lychgate entrance to the church, and have survived because they were protected by an iron cage ninety years ago. Unusually, the stocks here also have a whipping post. Until 1820 women as well as men could legally be punished in this way, although it seems the practice had stopped some time before. (Historic England Archive)

Opposite above: Ducking Stool, Church of St Peter and St Paul, Leominster
Another form of punishment. There has probably been a ducking or cucking stool in Leominster Priory since early medieval times. The last time this particular stool was used was in 1809 when, by order of the magistrates, a woman named Jenny Pipes, alias Jane Corran, was paraded through the town on the stool and ducked in the water near Kenwater Bridge as a common scold (often poorer women labelled as a public nuisance). In 1895 the town council deposited the stool in the priory church where it has remained to this day. (Historic England Archive)

Opposite below: Interior of Crown Court, Hereford Shire Hall
Standing on the site of a former goal, the Shire Hall in Hereford was completed in 1819. It housed an Assize Crown Court, courts held periodically around the country to hear the more serious criminal trials. The court at Hereford was part of the Oxford Circuit, which took in most of the West Midland counties. Assize courts were abolished and replaced by permanent crown courts in 1971. (© Historic England Archive)

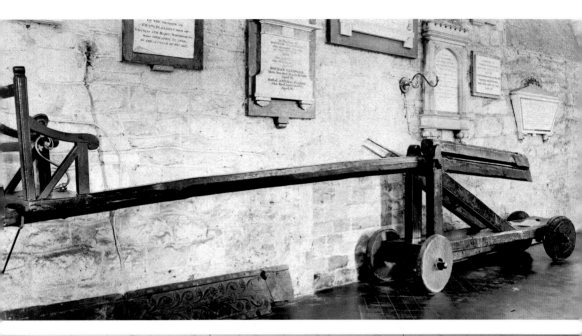

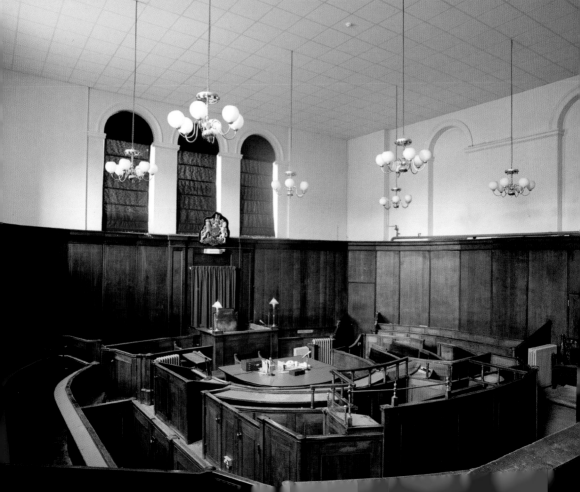

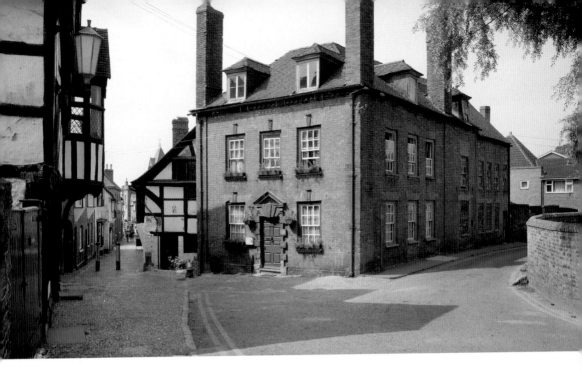

The Magistrates' Court, Church Street, Ledbury
Lesser crimes were tried in magistrates' courts. Built in the early eighteenth century, this imposing example is representative of the buildings towns put up to house them. The house is set at an angle to neighbouring buildings, and was extended as the police station in 1860. Described as the finest Georgian building in the town, with its striking symmetry and windows inset to accommodate corner fireplaces, it was almost demolished by the council in 1973 but was saved and ultimately restored after a prolonged campaign led by the Ledbury Society. (© Crown copyright. Historic England Archive)

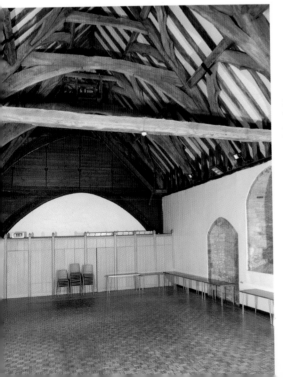

St Katherine's Hospital, High Street, Ledbury
The original hospital was founded by Bishop Hugh Foliot in around 1231, although no part of that building survives. This hall of around 1330 was both chapel and hospital. It was thought the inmates would prevent the chaplains neglecting their duties, and their numbers would increase the efficacy of the prayers. The beds of the inmates were arranged in rows along the walls to allow them to participate in the daily services. Medieval hospitals were heavily influenced by monastic life and run by brethren who did not take vows but still had to live communally in the hall under the firm leadership of a master. (© Historic England Archive)

Above: The West Elevations of the Master's House and St Katherine's Chapel, Ledbury
Medieval hospitals needed large estates to support them, and this picture gives an impression of the extent of just the immediate precinct of the hospital, which occupies two-thirds of the west side of the High Street. The master had considerable power and in the 1480s built a house for himself here reflecting his station in life. Much of the original building survives, albeit hidden within a brick façade. The house was restored recently and there are plans to recreate the garden space as a public square. (Historic England Archive)

Below: The Almshouses, St Katherine's Hospital, Ledbury
Possibly built on the site of a row of timber-framed buildings intended to house the brethren and sisters, these neat replacement almshouses were designed by Robert Smirke (see also Eastnor Castle, page 16) in 1822. A southern range was added in 1866. (© Historic England Archive)

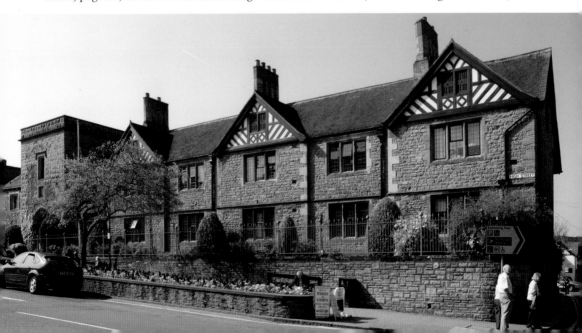

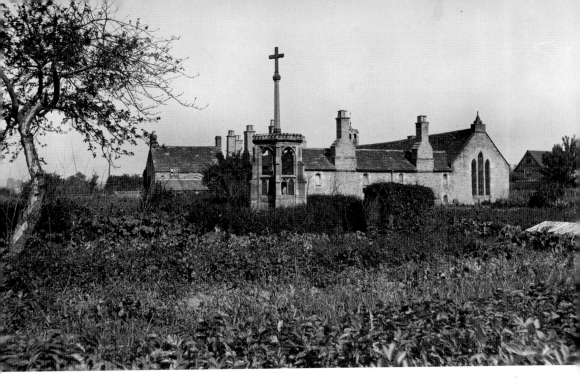

Coningsby Hospital and Chapel, Widemarsh Street, Hereford
This site was formerly occupied by a religious house of the Order of St John. In 1614 Sir Thomas Coningsby used stone from the medieval chapel and hospital here to create a hospital of twelve cottages for old soldiers with a chapel, refectory and offices. The houses were administered by a chaplain who lived on-site, whose duties included preaching sermons and marching the pensioners to Hereford Cathedral each Sunday. (Historic England Archive)

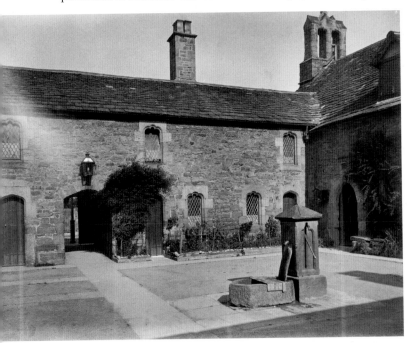

Coningsby Hospital Courtyard, Widemarsh Street, Hereford
The almshouses opened onto this courtyard. The soldiers were given free food and fuel and received a weekly allowance. The Coningsby pensioners wore a uniform of redcoats, leading to the legend that Nell Gwynne chose redcoats as a uniform for the Chelsea Hospital because she remembered the Coningsby pensioners from her childhood in Hereford. (Historic England Archive)

Rudhall Almshouses, Church Street, Ross-on-Wye

Taken from the curved steps of St Mary's churchyard, this photograph looks towards the almshouses on the other side of Church Street. Founded in the fourteenth century and rebuilt by William Rudhall in 1575, this row of five almshouses were occupied by poor men or women. In the 1870s each resident was given an annual allowance of 30s. The number of houses was reduced to three in 1960, without altering the outward appearance of the buildings. (Historic England Archive)

Staff and Patients' Sitting Room, St Mary's Hospital, Burghill

Originally opened in 1871, at its height the Hereford Lunatic Asylum could accommodate 550 patients. It was renamed the Burghill Mental Hospital in the 1930s, and later became St Mary's Hospital as part of the National Health Service. The hospital's estate included a chapel, an isolation hospital and administrative accommodation along with a gasworks, workshops and laundries. If they were able, patients worked on the estate. Opinion has now moved away from these large institutions for the treatment of mental illness and the main buildings were demolished when the hospital closed in 1994. (Historic England Archive)

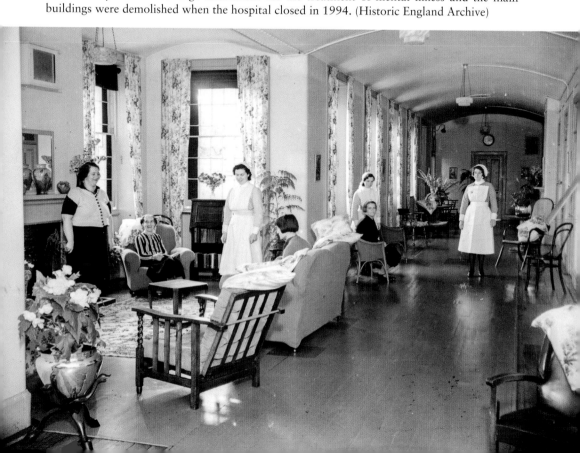

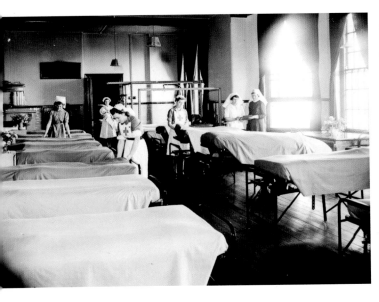

The Emergency Ward at St Mary's Hospital, Burghill The Emergency Medical Services scheme was established in 1938 to reorganise healthcare and prepare for casualty treatment in case of war. Beds in St Mary's were requisitioned as part of the scheme, the light and well-equipped wards being ideal for the purpose. The large windows in the wards were a feature of the hospital, as the views and sunlight were regarded as therapeutic. (Historic England Archive)

Dilwyn Vicarage, Dilwyn
During the Second World War the author J. B. Priestley and his wife established hostels to provide accommodation for mothers, babies and young children evacuated from bombed cities. Dilwyn Rectory was one of the buildings used as a Priestley nursery, and the hostels also provided training for students undertaking the National Day Nursery diploma. (Historic England Archive)

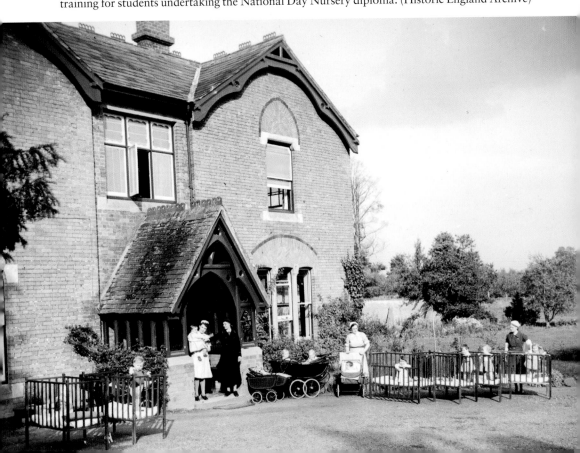

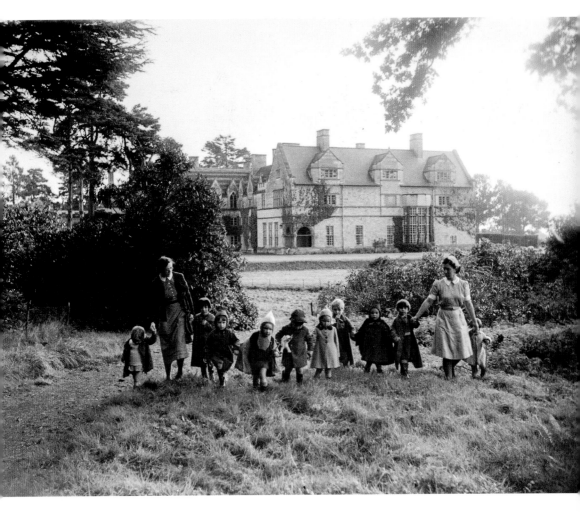

Broxwood Court, Pembridge

The Priestleys used their own house at Broxwood Court to accommodate mothers as well as children. Here evacuated children and their nurses set off from Broxwood on a walk. Mothers staying at the hostel took on domestic duties, and received 'practical lessons in mother craft'. By the end of 1941 the Priestleys had established seven hostels where mothers from bombed cities could live with their evacuated children. In just three days in 1939 over 1.5 million children were evacuated from cities to rural locations, and in contrast to the Priestley homes, almost all were sent to live with strangers. (Historic England Archive)

The Railways

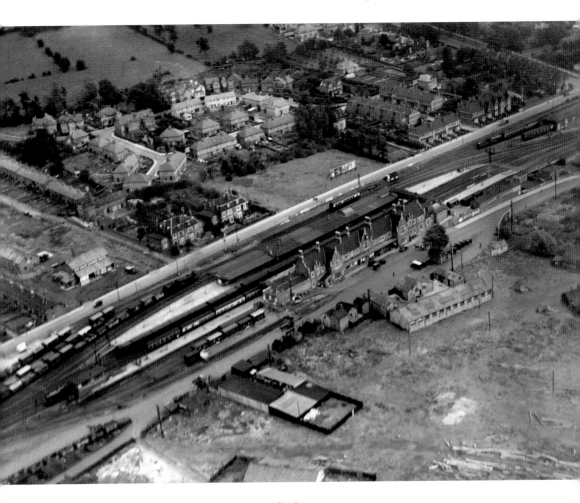

Above: Barrs Court Railway Station, Hereford
This part of Hereford has a long history as a centre for communications. The site in the foreground was formerly the terminal wharves of the Herefordshire & Gloucestershire Canal. Barrs Court was developed as a new station in 1853, when the Barton station in the west of the city could not be extended to serve the coming of the Shrewsbury line from the north. The Barrs Court station was later remodelled in the Victorian Gothic style and its name simplified to 'Hereford' in 1893 when the Barton station closed to passengers. (© Historic England Archive)

Opposite below: The Ballingham or Carey Bridge across the Wye
In 1780 the crossing here was known as James Ford. Later it became Careyboat, and a ferryman's house stood on the bank where a steep path led up to the Yew Tree or Wood Inn. Building a railway here presented significant engineering challenges including this remarkable bridge over the river. Following pressure form the local landowner, Ballingham station was opened nearby in 1908 but had a limited service and was never fully used. After closure of the line the deck was removed and today only the piers of the bridge remain. (Historic England Archive)

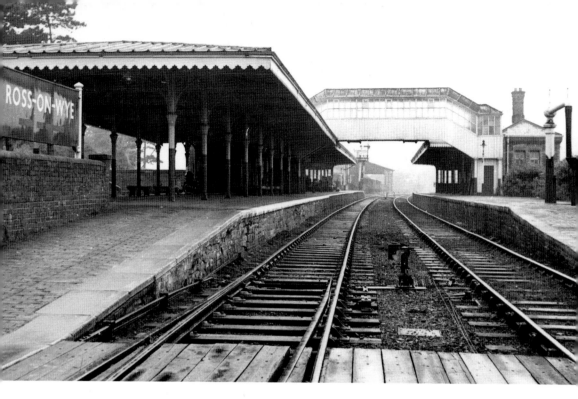

Above: Ross-on-Wye Station

Looking along the railway tracks at Ross-on-Wye station in the direction of Hereford, showing the footbridge and station buildings. The station was opened in June 1855 by the Hereford, Ross & Gloucester Railway, which amalgamated with the Great Western Railway seven years later. Although the station also acted as a terminus for the Monmouth Railway, it closed in stages, with the final train leaving on 31 October 1964, just a month after this photograph was taken. The main station building was demolished and the site redeveloped as an industrial estate. The brick engine and goods sheds still stand. (Historic England Archive)

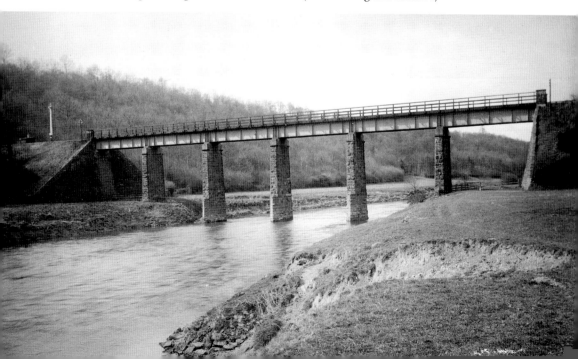

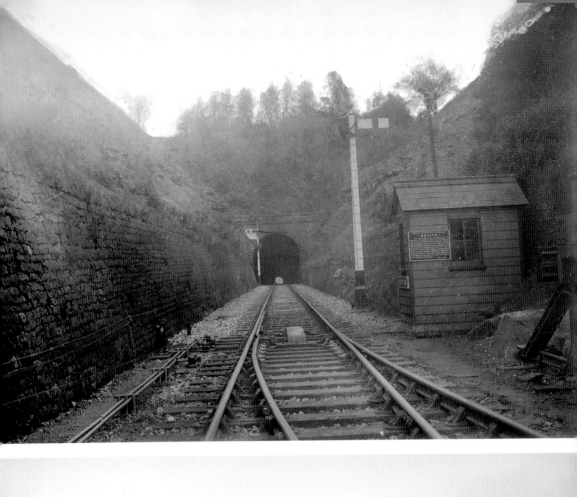

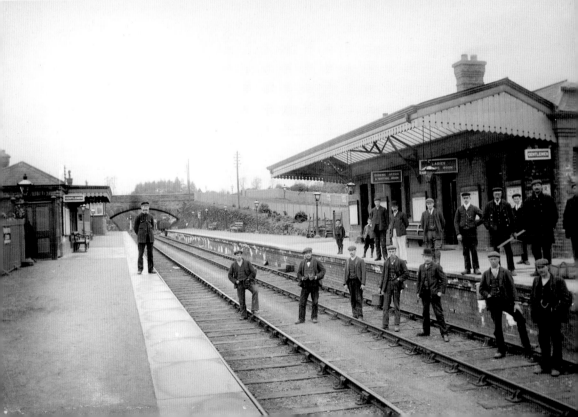

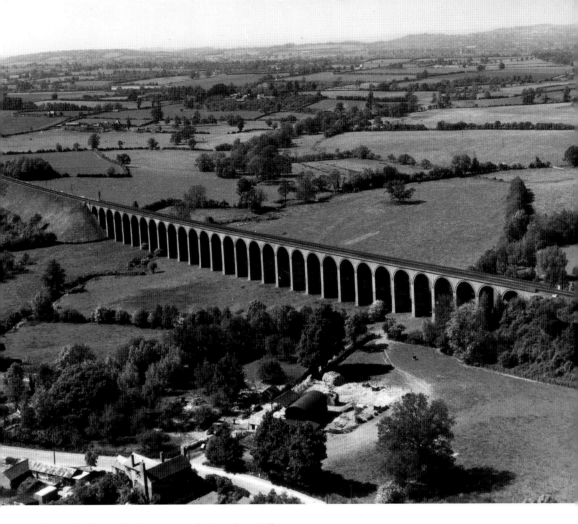

Above: Ledbury Viaduct across the Leadon Valley

A rail link between the industries of the Midlands with the coalfields of South Wales was first proposed in the 1850s. The original plan was to take a direct route, but after successful lobbying by the citizens of Malvern and Ledbury the line was diverted through their towns, linking Worcester to Hereford via a series of tunnels and viaducts. The impressive Ledbury Viaduct was probably designed by Stephen Ballard and was opened in 1861. The 5 million bricks used to build the thirty-one arches were made on-site from the clay dug out for the foundations. (© Historic England Archive)

Opposite above: Fawley Tunnel, Kings Caple

After crossing Ballingham Bridge southbound trains entered this tunnel to emerge at Fawley station. At 1,105 metres (1,208 yards) long the Fawley Tunnel was driven through the ridge on the south bank of the Wye and is nearly completely straight other than a slight turn to the east near the southern portal. (Historic England Archive)

Opposite below: Fawley Station, Kings Caple

One of the two original stations on the Hereford–Ross line, this picture shows the station staff and a railway crew who were undertaking repair work on the line at the time. The railways were significant employers, and even small stations could have a stationmaster, clerks, porters, goods staff and signalmen to run them. (Historic England Archive)

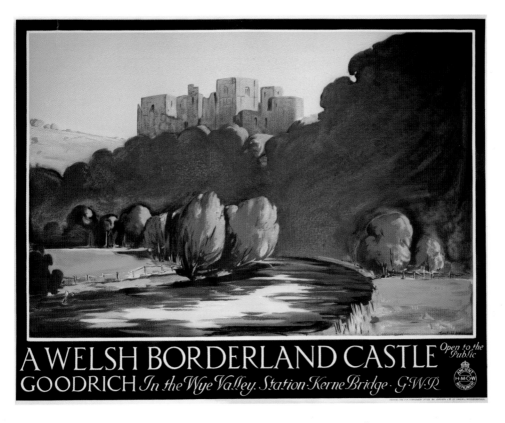

A WELSH BORDERLAND CASTLE *Open to the Public*
GOODRICH *In the Wye Valley. Station-Kerne Bridge · G·W·R*

Above: Poster Advertising Goodrich Castle for the Great Western Railway
This was one of a series of posters produced by the GWR to promote tourist travel to Herefordshire and the Wye Valley. Through these posters, and also publishing a volume on the Wye Valley in 1924 in its 'Handy-Aid' guide series, the company can take much of the credit for opening up this area to modern tourists. (Historic England Archive)

Opposite above: Westmoor Flag Station, Mansell Lacy
Built in 1863, this station in Mansell Lacy served as a private station for the Davenport estate. As the only brick-built station on the Hereford–Three Cocks line, this had a unique design with a two-storey addition, or loggia, from which the stationmaster hung out a flag when a train was required to stop. The station closed in 1962 and this Grade II listed building is now a house. (© Crown copyright. Historic England Archive)

Opposite below: Eardisley Railway Station
This building at Eardisley is much more representative of the stations built on the Hereford, Hay & Brecon Railway line. Opened in June 1863 on the Kington & Eardisley Railway, this line replaced an earlier horse-drawn tramway between Brecon, Eardisley and Kington – which at 36 miles was longest continuous plateway laid in the country. The station closed in 1964 and as shown here fell into disrepair; however, the main building was rescued and rebuilt as a feature of the volunteer-run Welshpool & Llanfair Light Railway. (© Crown copyright. Historic England Archive)

The River Wye

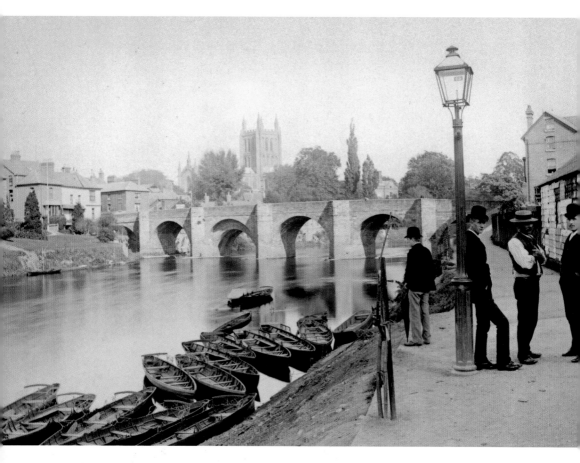

Above: The Wye Bridge, Hereford
Before the building of the Wilton Bridge this was the only bridge over the Wye in the county. The current bridge is thought to date from 1490, but this site has probably been used as a crossing point since pre-Conquest times. Despite the difficulties in using the Wye and its tributary, the Lugg, for transporting goods, the river in Hereford has always been widely used for pleasure boating. The boats moored on the south side of the river in the picture were owned by Jordan's Boatyard, who operated a hire service on this site for nearly eighty years. (Historic England Archive)

Opposite below: The Wye Bridge, Hereford
Taken from a very similar viewpoint as the pictures above, the 1920s showroom of Mead & Tomkinson is just beyond the bridge. The company also had a showroom in Tewksbury and came into prominence in the mid-1970s with their specially designed endurance racing motorbike. Nicknamed 'Nessie', because like the famous monster it was not a thing of beauty, the bike nevertheless had many innovative features later adopted in other manufacturers. Since 2000 the site of the showroom has been occupied by the Left Bank bar and restaurant complex.

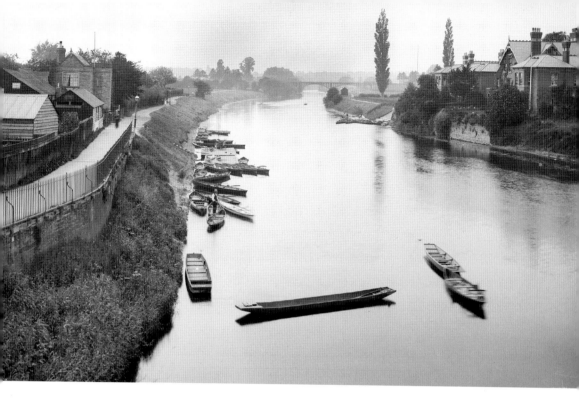

Above: A View West from the Wye Bridge
The taller building on the left is the terminus and ticket office for the horse-drawn Abergavenny and Hereford Tramway, which operated between 1829 and 1853. All these buildings were demolished to make way for the new A49 road bridge, although the embankment carrying the tramway across the meadows south of the Wye can still be seen today alongside the boundary of the supermarket. (Historic England Archive)

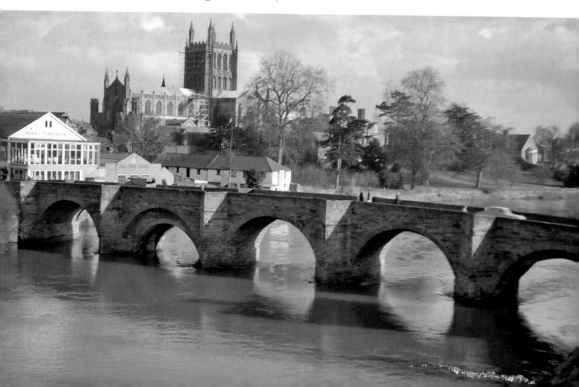

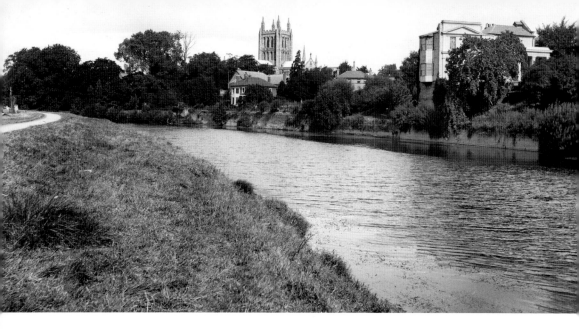

Above: The River Wye in Hereford: General View towards Castle Cliffe and the Cathedral
This view from Bartonsham Meadows frames the cathedral and the Castle Green Pavilion, in use as an art college. This picture was taken before the freehold of the meadow was donated to the city in 1937, and before the avenues of beech trees were planted. (Historic England Archive)

Below: The River Wye and Hereford from the West
A view of Hereford and the Wye few would recognise today. The growth of the city has completely covered the open fields to the right (south) of the picture with the Belmont and Lower Bullingham developments. The countryside here is set for more development as the city's bypass is planned to run through this area. (© Historic England Archive)

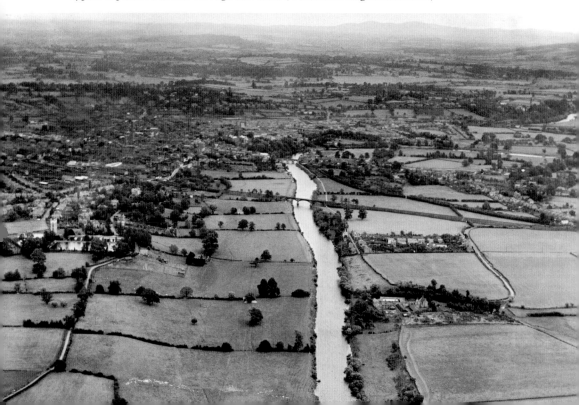

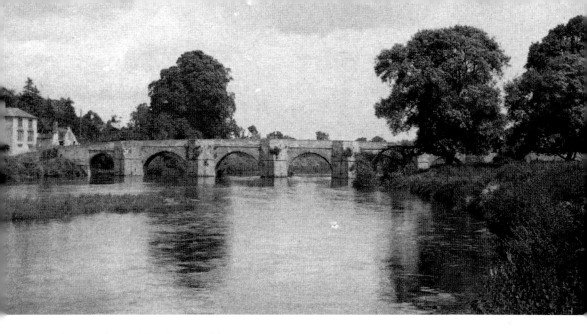

Above: Wilton Bridge, Ross-on-Wye

Although the Wye at Ross was easy to ford in summer, in winter it became impassable and a wooden bridge or a ferry was the only way to cross. In 1597 Parliament directed that a stone bridge be built here following the sinking of a ferry that resulted in the loss of forty lives. This was to be paid for by tax on every town and village in the county apart from Hereford, although the ferryman was granted the right to collect tolls as compensation for his loss of rights. As at Hereford, part of this bridge was removed during the Civil War and the replacement arch now differs from the rest. (Historic England Archive)

Below: A View across the River Wye towards Ross-on-Wye

While two men set off in a rowing boat, a third is carrying a coracle on his back. A coracle is a small lightweight riverboat built of a basketwork of laths covered in canvas coated in pitch or bitumen to make it waterproof. Historically the coracle could be found throughout the country, but today they are associated primarily with parts of Wales where they continue to be used for fishing. (Historic England Archive)

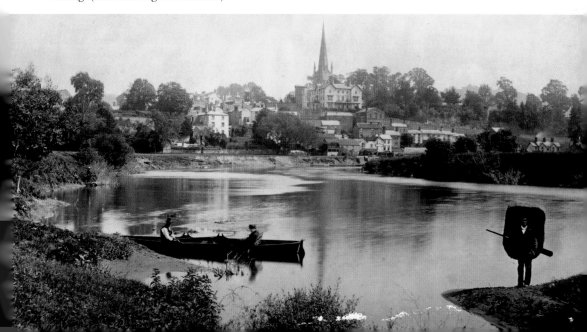

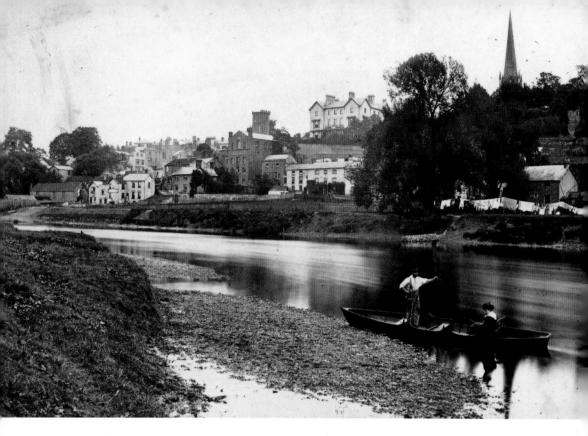

Across the River Wye towards Ross-on-Wye
Herefordshire has a series of market towns as satellites to central Hereford, but only Ross is on the River Wye. In 1745 the local rector started taking his friends on pleasure trips down the river to admire the scenery. The fashion grew, and the publication of Gilpin's *Observations of the River Wye* in 1782 helped travellers locate and enjoy the most picturesque aspects of the countryside. The Wye was one of the first of Britain's landscapes to be 'discovered', witnessing the birth of British tourism. (Historic England Archive)

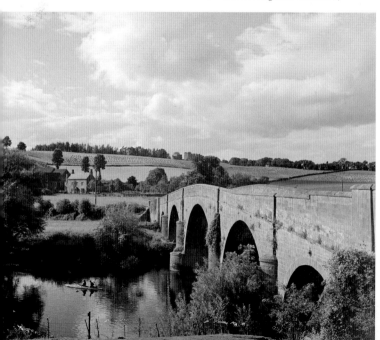

Kerne Bridge, Walford
The Kerne Bridge carries a road over the Wye around 6 km (3.5 miles) south of Ross-on-Wye. The nearest hamlet was originally known as 'the Quern' but changed its name soon after the bridge was built in 1828. It is fitting that the photograph shows two people in a tandem kayak as the former railway station site near the bridge has been used as a canoe-launching site for many years.
(© Historic England Archive)

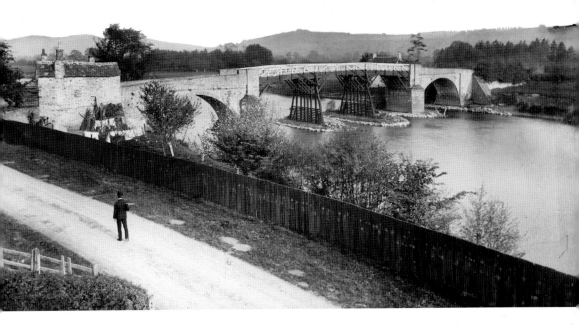

Above: Whitney Toll Bridge

The Whitney Bridge was built on a section of the River Wye that, as at Ross, could only be crossed at unpredictable fording places. The first bridge was completed in the 1770s, but was swept away by the river. A similar fate befell the next two bridges, until a new consortium built the current, much more substantial, bridge in 1798. One of only eight privately owned bridges in the country, by Act of Parliament the owners are allowed to charge a toll to recoup the building costs, completely tax-free. (Historic England Archive)

Below: Symonds Yat, Goodrich, Forest of Dean

Symonds Yat continues to delight tourists to this day. The name Symonds Yat is said to come from Robert Symonds, a seventeenth-century sheriff of Herefordshire, and 'yat', an old word for a 'gate' or 'pass'. By controlling the river at this point Symonds could control all the river trade in and out of Herefordshire. (Historic England Archive)

General View across the River Arrow, Kington
The Arrow is a tributary of the Wye, forming part of the boundary between England and Wales before winding its way through Herefordshire. It supports an abundance of wildlife, including otters, along the way. Seen here in Kington, it flows through the recreation ground. Gifted to the town over a century ago, the 'Rec' was first managed by a charitable trust before being handed over to the town council. (Historic England Archive)

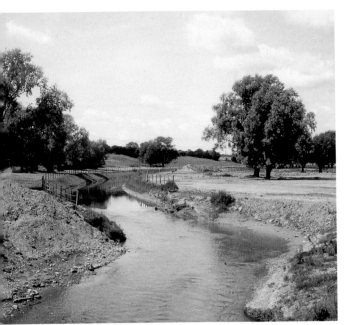

River Lugg
Another tributary of the Wye, the Lugg rises over the border in Powys and flows through Leominster to join the Arrow and ultimately the Wye at Mordiford. Attempts to make it navigable were never wholly successful, and in recent years the focus has been on flood prevention. The River Lugg Drainage Board was formed in 1920 to manage water levels on the river. In the 1960s there were major works on the river to prevent the regular flooding that befell Leominster.

The Market Towns

Right: The Man of Ross Public House, Ross-on-Wye
Although housed in a seventeenth-century building, this inn opened in 1847. The plaque on the gable wall commemorates John Kyrle, the son of a wealthy family who inherited a house in Ross overlooking the market square. His name is honoured throughout the town because instead of indulging his wealth Kyrle used his money to further the welfare of the town and its people. (Historic England Archive)

Below: Ross-on-Wye
A fine view of Ross and the Prospect Gardens overlooking a horseshoe bend of the River Wye. The gardens were laid out by John Kyrle in 1696 with viewpoints, walkways and a public fountain to provide clean water for residents. Over 300 years on, it is still open to the public. (© Historic England Archive)

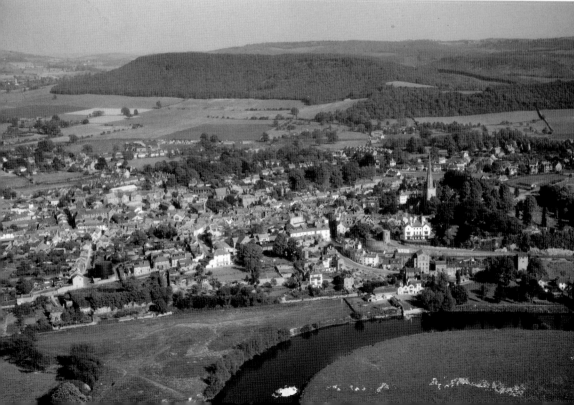

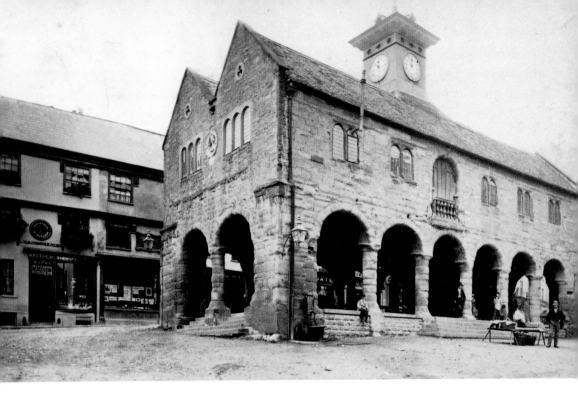

Market Hall, Ross-on-Wye
The open space on the ground floor of the hall was built in around 1650–60 as an open arcade for market stalls and storage. The upper floor was the home of the court leet, the court of record in the manorial system. This court ensured standards were maintained in farming and in sales of food and drink. It also tried all but the most serious crimes committed within its jurisdiction. These chambers were later used as a public library and council chamber, and were restored in 1997 to house the local heritage centre. (Historic England Archive)

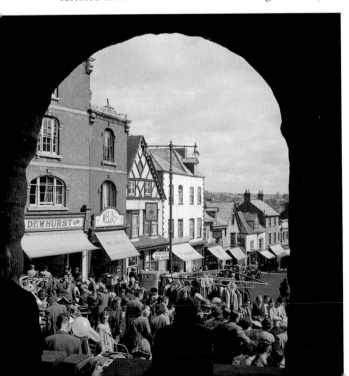

Market House, Broad Street, Ross-on-Wye
Ross was granted a charter by King Stephen in the twelfth century to hold a market each Thursday. The regular market in Ross is still held on that day and also on a Saturday. These regular markets are complemented by farmers' markets on the first Monday of each month. (© Historic England Archive)

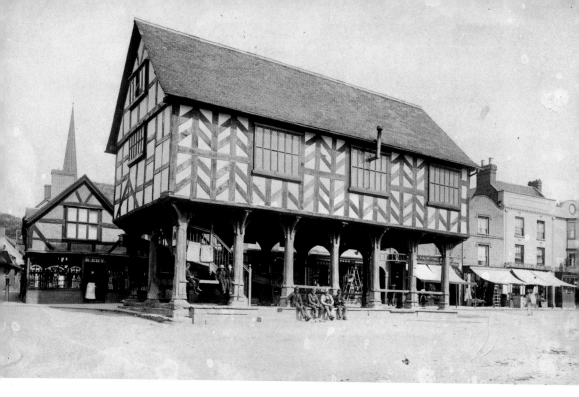

The High Street and Market House, Ledbury
Standing on its sixteen pillars in the heart of town, Ledbury's superb Market House is probably the best example of its kind in England. This Grade I listed building, built between 1617 and 1668, has been attributed to the king's carpenter, John Abel. Originally used for the storage of grain, wool and hops, it now hosts markets on Tuesdays and Saturdays. This nineteenth-century view shows figures sitting on the open ground floor while behind is a man standing in the doorway of the Ballard R. Edy grocers shop, on the corner of Church Lane. (Historic England Archive)

Church Lane, Ledbury
This much-photographed view is a favourite with many visitors to the town as an evocation of a time when overhanging buildings flanked narrow streets paved with cobbles. The lane leads from the marketplace to St Michael's Church, whose spire is in the background. It houses two of the oldest buildings in the town – the Old Grammar School and the Council Chamber – as well as the remarkably complete sixteenth-century Church House. (Historic England Archive)

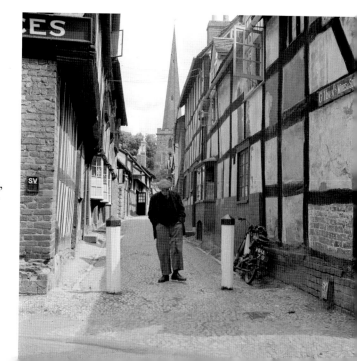

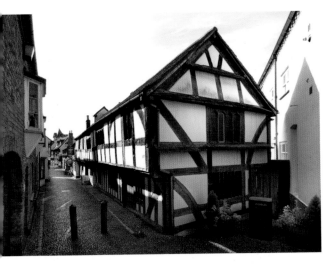

The Old Grammar School, Church Lane, Ledbury
This building may have started life in around 1480 as a civic building, possibly a guildhall. Early on it became a school of chantry foundation – a place where Mass was sung for the benefit of the donor – before becoming a grammar school in the sixteenth century. As the name suggests its main function was to teach Latin grammar in a school day that stretched from 7 a.m. to 4 p.m. It closed as a school in around 1860. (© Historic England Archive)

The Steppes, New Street, Ledbury
New Street was part of the planned medieval town, and along with the High Street, it benefited from many fine houses created during the great rebuilding between around 1570 and 1620. This was a revolution in design away from the open hall with central fires and communal living of the Middle Ages. The new houses had a wide range of rooms to provide much more privacy and comfort, and of course a façade that allowed their owners a suitably modest display of their affluence. (© Historic England Archive)

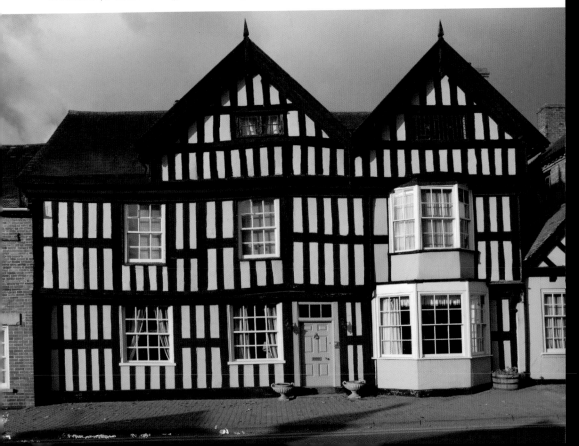

No. 2 High Street, Ledbury
Towards the end of the eighteenth century the Tudor style was distinctly unfashionable and Ledbury's more refined inhabitants craved the latest styles. Old buildings were demolished or, where their owners could not afford to rebuild, given a makeover. Timber was covered in stucco to imitate stone or, as here, the façade was rebuilt in brick and the jetties underbuilt. This particular building is now run by a national chain but it has been a baker's shop for at least 130 years. (Historic England Archive)

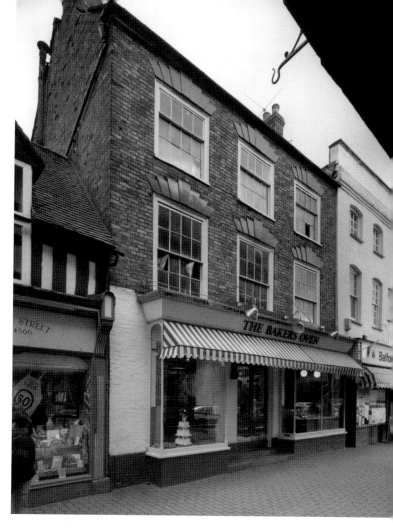

Boots, No. 9 High Street, Ledbury
This building is a fine example of timber framing, hidden behind nineteenth-century stucco, until it was revealed in around 1950. The narrow vertical panels created by the close-studded timber are a characteristic feature of many of Ledbury's buildings. The small additional glazed lights set high above the main windows, possibly to provide light when the shutters on the main windows were closed, are also a distinctive local feature. (© Historic England Archive)

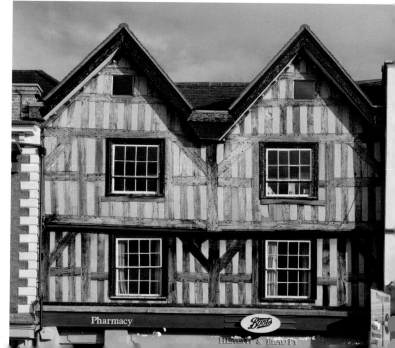

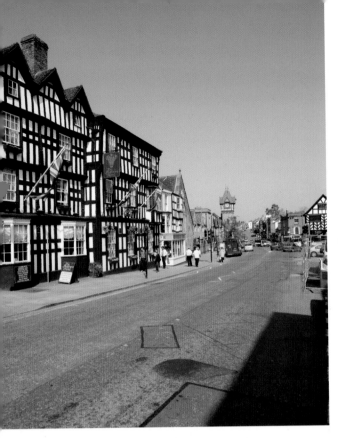

The Feathers Hotel and High Street, Ledbury
Originally known as the Plume of Feathers, this was once the main coaching inn in Ledbury. Dated by its style to around 1570, this spectacular building has three close-studded storeys, each projecting slightly above the other. An attic of five gables was added when the house on the right was built – made to emulate its imposing neighbour. (© Historic England Archive)

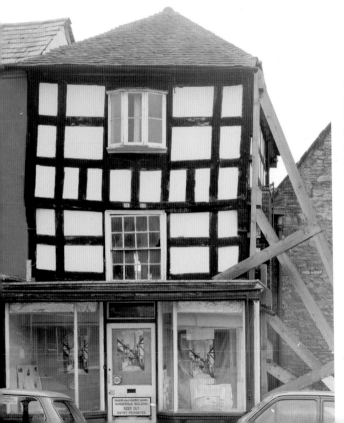

No. 27 High Street, Ledbury
Many buildings on the High Street have been adapted to modern use, and the shopfront projecting from this half-timbered house was added in the twentieth century. Although the ground floors of these buildings have become shops, the original buildings were often domestic and the upper levels may show much of their history, as here, where one of the beams bears the initial 'H' and the date '1695'. In fact the building has been tree-ring dated to 1675, but either date would make this a comparatively late example of timber framing at a time when building in brick was becoming fashionable. (© Historic England Archive)

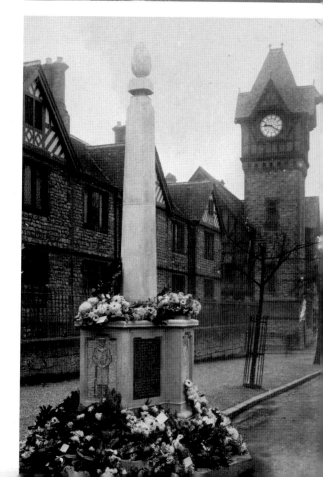

The Tower of the Elizabeth Barrett
Browning Memorial Institute
The idea of a clock tower as a memorial to
the Ledbury poet Elizabeth Barrett-Browning
was first mooted in 1890. What began as
a £50 donation for a modest town clock
soon grew to become an ambitious plan for
a complete institution at Hope End, which
was funded by public subscription and cost
£2,300. The town reading room moved into
the ground floor as soon as it was opened,
and in 1938 the institute became the public
library. (© Historic England Archive)

The First World War Memorial, Ledbury
Ledbury lost seventy-one men in the First
World War. The memorial was unveiled in
the High Street in front of St Katherine's
Hospital in 1920 and features mosaic
plaques depicting a soldier, a seaman and
an angel (fifty-four names and a mosaic
of an airman was added after the Second
World War). The War Memorial Fund also
purchased a recreation ground to the south
of the town. This was handed over to the
town council in 1926 'for the benefit of the
youths and children residing in Ledbury
and as a memorial to the fallen of the
Great War'. (Historic England Archive)

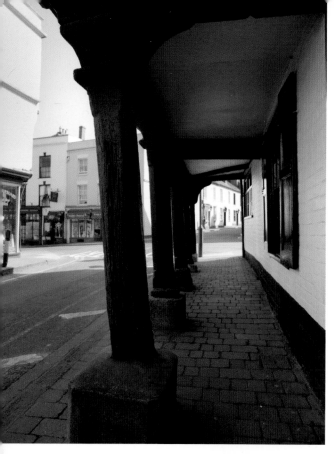

Left: Nos 1–2 The Southend, Ledbury
While Nos 1 and 2 of The Southend
have many of the features of Ledbury
buildings of this period – close-studding,
attic gables and jetties – they are unusual
in that the upper floor is supported on
four posts and oversails the footpath.
(© Historic England Archive)

Below: The Market Theatre, Ledbury
For over forty years the Ledbury
Amateur Dramatic Society performed
in the Old Market Theatre – a
former corrugated-iron church hall.
After lengthy fundraising efforts
this was replaced in 2000 by this
purpose-built theatre. Today this
is a vibrant community resource
hosting amateur and professional
theatrical productions as well as films.
(© Historic England Archive)

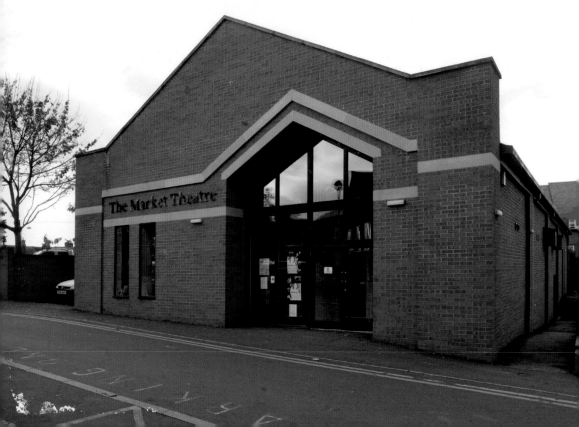

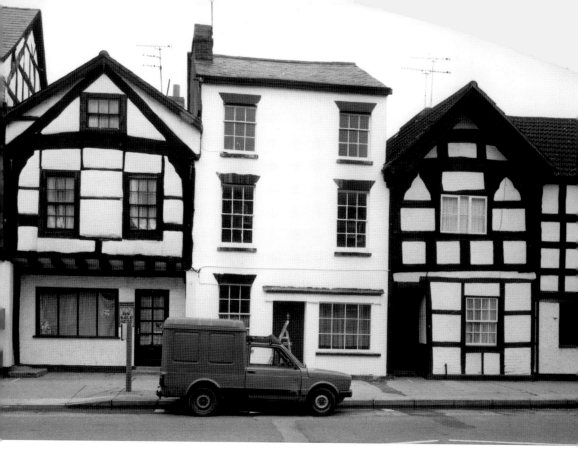

Above: Nos 25–29 Bridge Street, Leominster
These houses are thought to have been
built in the late fourteenth or early fifteenth
century, possibly dating the growth of
the town north of the River Kenchester.
Although much altered, these buildings are
the upper and lower crosswings of a modified
timber-framed house. (Historic England
Archive)

Right: The Grange, Leominster
The prosperity of the early seventeenth
century spread across the county. Built by
John Abel in 1633, the 'Old Town Hall'
originally stood in the centre of town at the
junction of Broad Street and High Street.
It was rebuilt on its present site in 1859.
When this photograph was taken it was used
as a private house by Mr Henry Moore, a
prominent local solicitor. In 2004 the freehold
was transferred to the Leominster Area
Regeneration Company Ltd (LARC) and the
building was refurbished as a community
facility. (Historic England Archive)

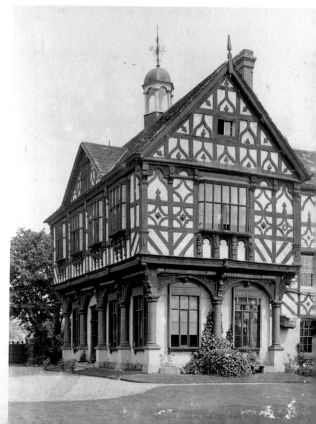

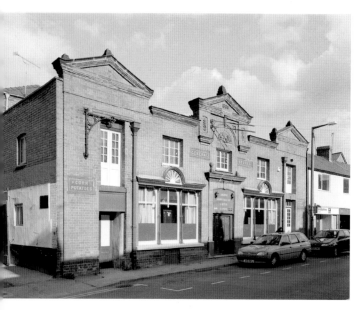

Former Hinton's General Stores, Rainbow Street, Leominster
Hinton's are a long-established trading family in Leominster. George Felton Hinton opened this agricultural merchants in Rainbow Street in 1885. He carried on business there until around 1911 when he sold out to George Foster. Many in Leominster still call this building Fosters, although it ceased trading in 1970. The building is now used as a social club, but it retains many reminders of its past, including most of the signage and even the pulley used to raise sacks to the upper floor. (© Historic England Archive)

Etnam Street and Watsons Motor Works, Leominster
Although Etnam Street was the main road connecting Leominster with the West Midlands, this thoroughfare contained few public buildings. Instead it grew as a residential area interspersed with small businesses and shops. This mixed use is typified in this view of the south side of Etnam Street, which has Leominster Museum, still run entirely by volunteers; the garage operated by Watsons since 1913 beyond; and in the distance the gable of the building at the end of the street is Dutton House, a fine Victorian Gothic shell around a sixteenth-century core. (© Historic England Archive)

The City of Hereford

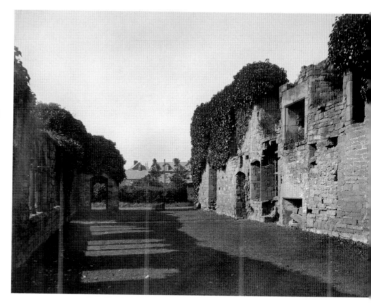

The Remains of
Blackfriars Priory
The Dominicans appear to have
acquired this site in Widemarsh
from the city in 1322. The
major part of monastery,
including the church, was
destroyed following the
Dissolution of the Monasteries
under Henry VIII and only
parts of the refectory and the
prior's house were left standing.
Portions of the buildings
were retained as a house.
(Historic England Archive)

Blackfriars Priory
Preaching Cross
Two men and a woman stand
beside the preaching cross in
front of the ruins of Blackfriars
Priory in this Victorian
study. The preaching cross in
Hereford is the only surviving
example in the country of
the crosses erected by the
friars in their cemeteries. It is
hexagonal in plan and stands
on four steps supporting
three-stage buttresses at the
angles. The interior has a stone
bench around a central pier
with six small shafts rising
to the stone vaults. The cross
was restored soon after
this photograph was taken.
(Historic England Archive)

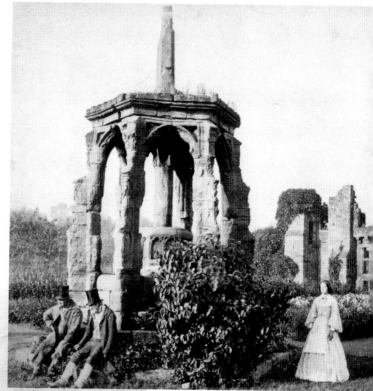

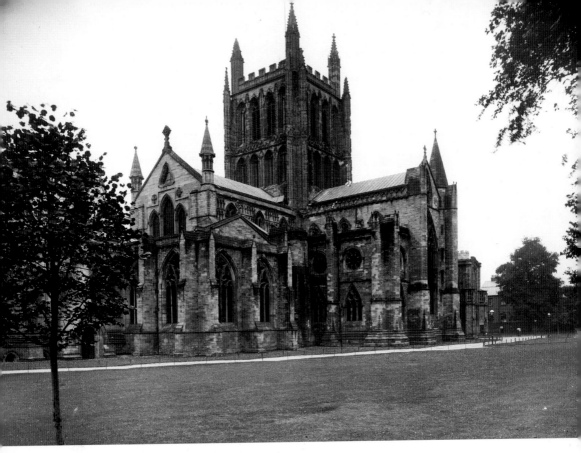

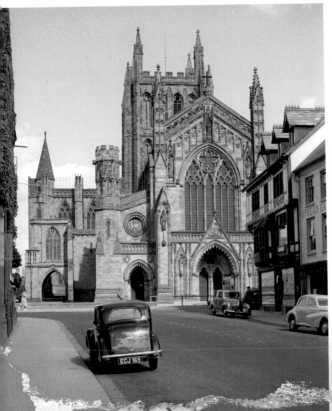

Above: Hereford Cathedral and Cathedral Close

Hereford is thought to have been the centre of a diocese as early as the 670s, but the early cathedral was destroyed by the revolt by Gruffydd ap Llywelyn in 1055. Rebuilding started in 1079, but it was to take another 440 years of building and rebuilding before it approached the form we see today. (Historic England Archive)

Left: The West Front of the Cathedral from King Street

A great disaster befell the cathedral on Easter Monday 1786 when the west tower fell, reducing this part of the building to a rubble. After immediate repairs, the full restoration did not start until 1841, progressing to the final work to create the ornate façade by John Oldrid Scott between 1902 and 1908. (Historic England Archive)

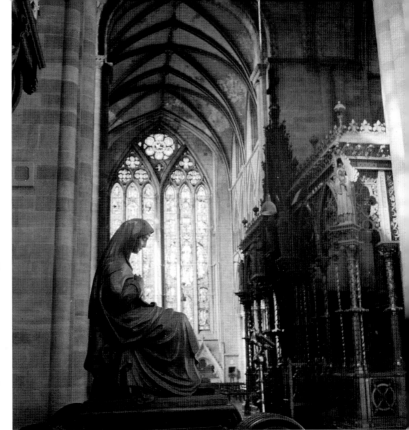

Interior of the Cathedral
The north transept
was built by Bishop
Aquablanca and restored
by Gilbert Scott, and it
fittingly provides the site
for the bishop's tomb, the
most ancient episcopal
monument in the church.
The overall effect of the
architecture is striking,
as the pointed arches
and windows here have
such a gentle curvature
they almost resemble two
straight lines meeting
at an angle. (Historic
England Archive)

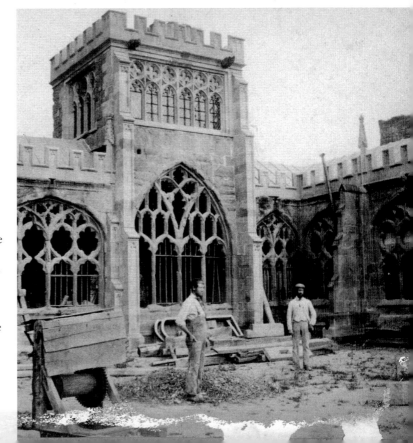

The Cathedral Cloister
The cloister was
originally constructed
as a place for the
twenty-seven men of
the Vicars Choral to
live and study. The
vicars sang services in
the cathedral, and the
tradition continues as the
cloisters are still home
to the music department.
The cathedral has just
been awarded a major
grant by the Heritage
Lottery Fund to renovate
and conserve this
tranquil area. (Historic
England Archive)

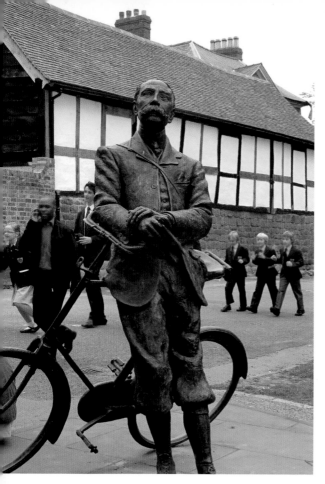

Statue of Sir Edward Elgar,
Cathedral Close
The Elgar family moved to 'Plas
Gwyn' in Hampton Park in July 1904,
a few days before Edward Elgar was
knighted. Elgar stayed in Hereford
until 1911 and spent much of his
spare time cycling in the surrounding
countryside with his friend Dr Sinclair,
the cathedral organist and choirmaster.
The 2005 statue of Sir Edward leaning
on his bicycle and gazing at the cathedral
was designed by Jemma Pearson.
(© Historic England Archive)

Supposed Birthplace of Nell Gwynne,
Gwynne Street
It has long been supposed that Nell
Gwynne, actress and mistress of
Charles II, was born in Pipe Well Lane,
now renamed Gwynne Street. Her father
was reputedly an army captain who
turned to brewing in his family's home
town after the Civil War. Nell and her
sister moved to London, selling fruit from
a barrow in Covent Garden, and later
famously selling oranges in the Theatre
Royal, Drury Lane. She moved to the
stage where she came to the attention of
the king, bore him two sons, and gained
considerable wealth, power and influence.
(Historic England Archive)

Right: The Old House

The Old House has been a landmark in the centre of Hereford since its building in 1621 as part of Butchers Row – a line of houses across what is now High Town. The house was possibly built by a John Jones, a butcher, with a rather colourful family. Mary Jones, his wife, was indicted for being a drunkard and disturber of her neighbours in 1625, and he was found to be in debt in 1628. After John's death Mary continued to live in the house, and in 1661 was fined for allowing her pigs to roam. The house is shown here when it was occupied by the saddler George Smith, prior to restoration in 1882/3. (Historic England Archive)

Below: Commercial Street, St Peters Street and the Old House

The bulk of Butchers Row was demolished in 1825 as part of the city improvements, leaving only the Old House. The house was refurbished by Lloyds Bank when the ground floor was altered, the shop frontage and additional door removed from the south façade and new decorative carvings added. At the time of the photograph the house was still in use as a bank. It was handed over to the city as a museum in 1928 when the house was further restored and many architectural features taken from other houses in the city added to it. (Historic England Archive)

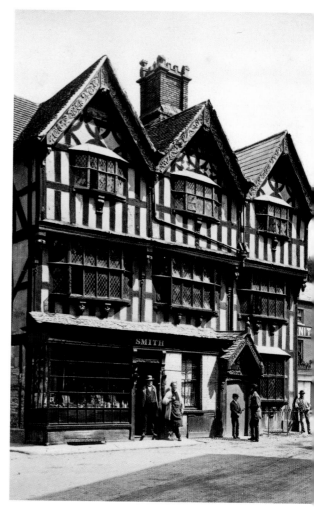

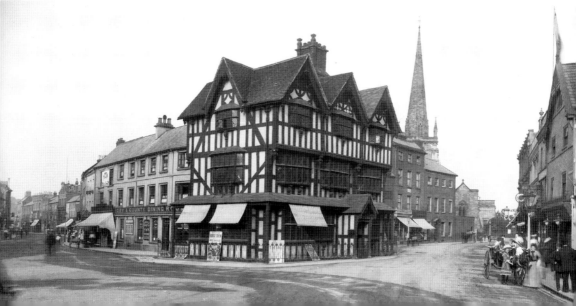

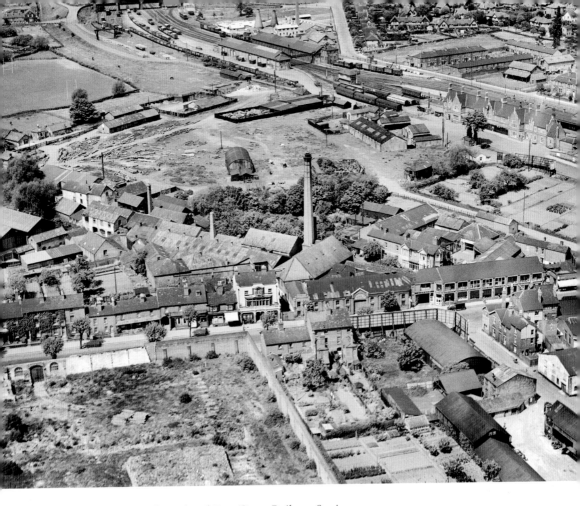

Above: Commercial Road and Bars Court Railway Station

This photograph captures a much-changed Hereford. The Commercial Hotel in the centre of the photograph is still there, but the 'skinyard' of Monkmoor Mills, where the skins of the sheep killed in the slaughterhouse in Stonebow Road were processed, just a ten-minute walk from the city centre, has gone (replaced by a filling station). The buildings in front of the station (top right) were the GPO sorting offices, and some of the buildings between them and Commercial Road housed a timber yard and a factory making motor and later aircraft components. The large area of open land in the foreground marks the site of the recently demolished Hereford Prison. (© Historic England Archive)

Opposite above: Castle Green

The site of an early monastic community, and later a pre-Conquest castle probably destroyed by the Welsh revolt of 1055. The castle was rebuilt after this but declined in importance and was demolished after the Civil War. Castle Green was first used as a public park in 1753. It houses a memorial to Lord Nelson, a frequent visitor and freeman of the city. Sadly, Hereford couldn't afford a statue of the great man and used an urn instead. The building on the left housed an art college, and later council offices, and is currently owned by a community organisation. (Historic England Archive)

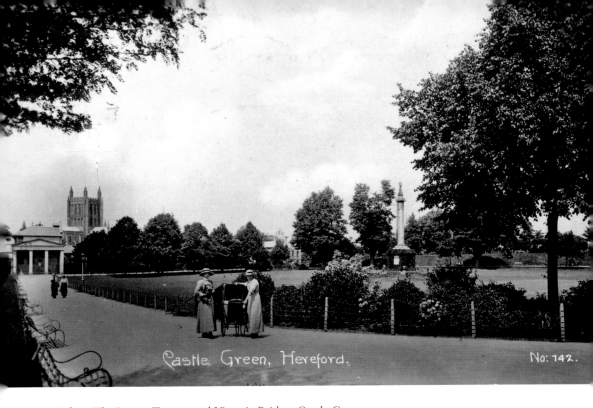

Castle Green, Hereford.

No: 142.

Below: The Lower Terrace and Victoria Bridge, Castle Green

Built on the site of a ferry across the river, the wrought-iron suspension bridge on the left of the picture was opened in 1898 to commemorate the Diamond Jubilee of Queen Victoria. The terrace near the river, much of it now sadly neglected, allowed a perfect spot to promenade and take the air. (Historic England Archive)

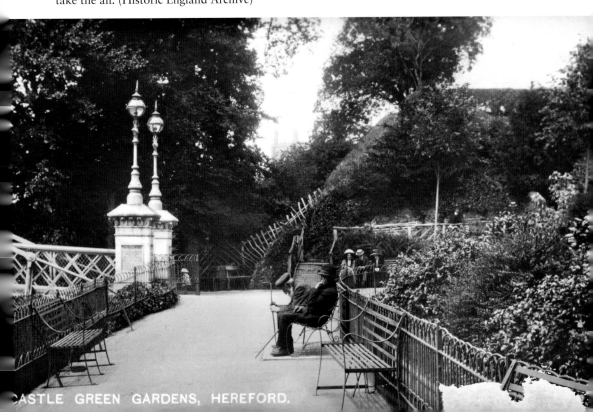

CASTLE GREEN GARDENS, HEREFORD.

Hereford Library, Museum and Art Gallery, Broad Street
The museum and library building was designed by F. R. Kempson and opened in 1874. The building cost £7,600, of which £6,100 was given by Sir James Rankin, the MP for Leominster, and the remainder by the Corporation. The architect F. R. Kempson moved to Hereford in the 1870s, and followed this building with many others in the city and surrounding area. Built in the then fashionable Gothic style, the façade is richly decorated with trefoil and quatrefoil designs, and carvings of animals by Robert and William Clarke. (© Historic England Archive)

Hereford Town Hall, St Owen Street
In 1900 the city fathers were looking for a suitable site for their new Town Hall when a valuable property in St Owen Street was donated to the city by a Mr Johnson. The council pressed ahead and accepted a design in terracotta and brick by Mr Cheers of Twickenham, before appointing a local builder, Mr Bowers, to carry out the work. When the building opened to much fanfare in June 1904 the *Hereford Times* proclaimed that it 'marked the birth of a new era for Hereford'. (© Historic England Archive)

Stereoscopic View of Broad Street and All Saints Church
An unusually quiet day on Broad Street, but the well-manured road surface is a reminder of how busy this thoroughfare could be. At the time the street was the site of periodic cattle markets, and was also the rank for horse-drawn taxis. By the late 1990s the spire of the church had a distinct twist to it and the top 22 metres (72 feet) had to be removed and rebuilt. (Historic England Archive)

Church Street
Linking the cathedral with High Town, this lane dates back to a street pattern laid out in the city 1,200 years ago. By the thirteenth century is was called 'Cabache' or 'Caboche' or 'Cabbage' Lane, where the wealthy churchmen purchased their vegetables, exotic herbs and spices. By the fifteenth century it was Cabeige Lane, and this was gentrified in the eighteenth century to Capuchin Lane, before becoming Church Lane 100 years later. The earlier name is preserved by Capuchin Yard (the entry is mid-picture). The street has always been concerned with trade and commerce, a tradition that continues. (Historic England Archive)

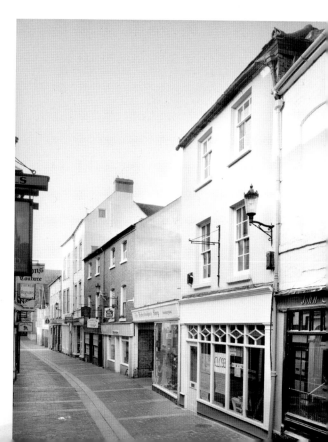

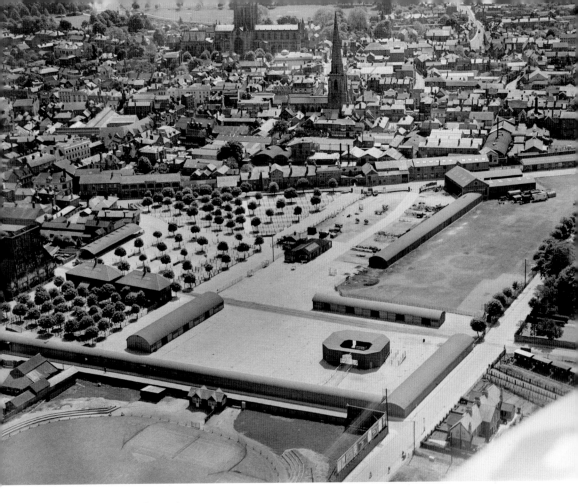

Above: The Cattle Market
Officially opened to the public in October 1856, the 'new' Cattle Market provided a dedicated venue for livestock sales, which until then had taken place in city streets. Over the years the market was expanded and improved with the provision of new sheds, and was even linked directly to the railway in 1914 by means of a branch from Barton Yard. In 2012 the market moved to a new home on the outskirts of the city and after 150 years of trading the old site was redeveloped. (© Historic England Archive)

Opposite above: Waterworks Museum, Former Site of Broomy Hill Pumping Station
Outbreaks of cholera and typhoid caused by infected water led to the building of the Hereford Waterworks. Work started in 1856 with the installation of a steam-drive-beam engine pumping water from the River Wye to a reservoir on Broomy Hill. As the population grew additional engines were installed, and a water tower was added in 1883 to increase water pressure in the higher areas of the city. Following its closure the buildings became a Waterworks Museum run by a charitable trust. (© Historic England Archive)

Opposite below: The View across Hereford from the Broomy Hill Pumping Station
The exact date of this photograph is uncertain but it may have been taken in around 1891 as this area continued to grow as a suburb to the west of the city. The new houses formed a ribbon of development along Broomy Hill Road and were generally larger dwellings within generous gardens. (Historic England Archive)

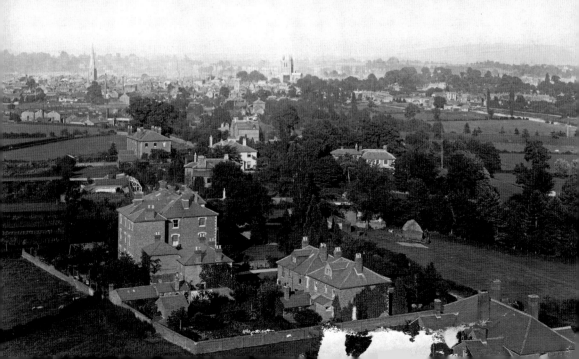

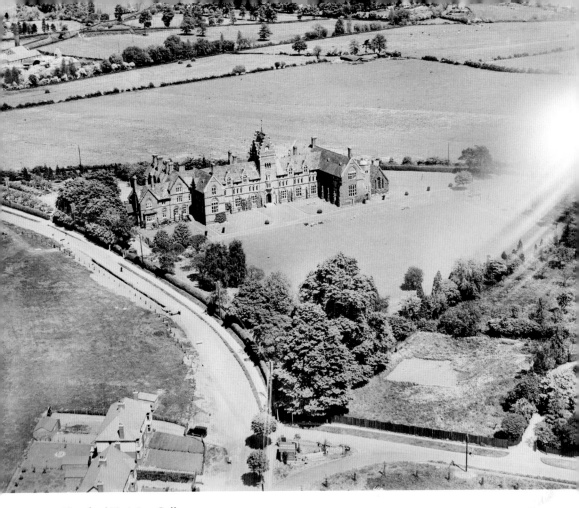

Hereford Training College

A boys' school occupied this building from its opening in 1880, but it was not a success and in 1904 it became an all-female teacher training college. This closed in 1978 and the buildings were taken over by the Royal National College for the Blind, the last of a number of moves for the college since its foundation in 1871. Following restructuring the RNC vacated this site in 2013 and the buildings become a campus for Hereford College of Arts. (© Historic England Archive)

Odeon Cinema, Commercial Street

The Odeon was one of the original cinemas of the Oscar Deutsch chain of Odeon theatres. The cinema cost £28,000 to build and this picture captures its opening week when it was showing a Will Hay film. The cinema passed through a number of owners, becoming successively Focus and Classic before closing for the last time in 1985. Despite efforts to preserve it, the building was demolished as part of the Maylords Orchard redevelopment. The Odeon clock was saved by the City Museum. (Historic England Archive)

Auditorium of the Odeon Cinema, Commercial Road

Seating was provided for 788 in the stalls and 345 in the circle. The dramatic auditorium was designed by Robert Satchwell and decorated in art deco style. Satchwell made extensive use of concealed lighting in the building; the screen was framed by large decorative splays and five long illuminated strips ending in a diamond design arching out over the front stalls. (Historic England Archive)

The William Evans Cider Works and Widemarsh Common Cricket Ground

Three lost industrial works in the city. William Evans set himself up as a cider merchant in Blue School Street in 1850. He was reasonably successful and sold out to the chemist William Chave in 1884. Evans then set up a new business in larger premises in Widemarsh Common. The company began to specialise in the production of pectin for jam production, and during the Second World War this became the centre for national production. The works was ultimately taken over by Bulmers in 1960 and pectin production moved to another site. (© Historic England Archive)

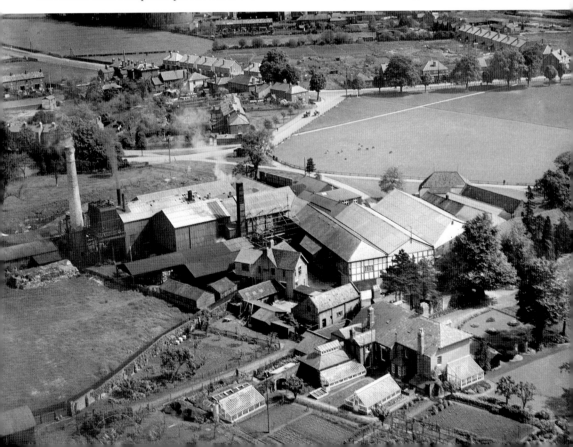

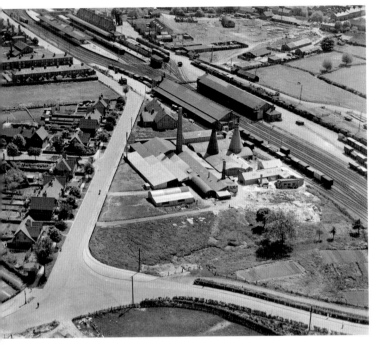

Jeffrey Tile Works, Barrs Court Road
John George Mowbray Jeffrey hailed from Manchester and was a student at the Coalbrookdale School of Art, where he was awarded a silver medal two years in succession. He worked as a designer for a decorative tile maker in Staffordshire before becoming a manager, and in 1927 he opened his own works making glazed decorative tiles in Hereford. His son took over the works and Jeffrey Snr died in Hereford in 1954, four years before his business was taken over by H. & R. Johnson Ltd.
(© Historic England Archive)

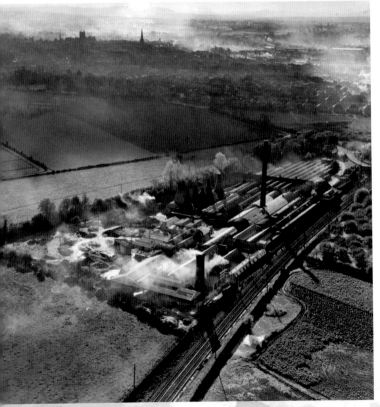

Victoria Tile Works from the North-east, Holmer
In its day the Victoria tile works was the largest in the county and famous for its wide range of fine enamelled and embossed tiles for fireplaces. The works was started in 1870 by William Godwin in 6 acres of clay beds and grew to contain a 160-foot-tall chimney and the large complex of buildings in the picture. The chimney was demolished in the late 1960s and by 1980 the tile works had closed. The site now houses the Holmer Industrial Estate.
(© Historic England Archive)

Acknowledgements

I am grateful to the trustees of Leominster Museum for permission to reproduce photographs from a slide collection donated by a volunteer to their picture archive. Unfortunately it has not been possible to identify the photographers and the author would be interested to hear from any readers who might be able to help in this respect.

My thanks go to my colleague Nic Howes for his help and unfailing generosity in sharing his encyclopaedic knowledge of obscure corners of the county.

I am indebted to the publications of many local historians whose works have been invaluable in gathering the information in this book. Herefordshire is fortunate in having a thriving community of local historians who are generous in sharing their work with others. I wish to thank the contributors to websites and publications from the history societies of Bromyard, Dilwyn, Eardisland, Ewyas Lacy, Fownhope, Longtown, and Pembridge, together with the Herefordshire Through Time website. I would also like to acknowledge my debt to the incomparable work of historians Bruce Coplestone-Crow, Derek Foxton, Joe Hillaby, Heather Hurley, Duncan James, Sylvia Pinches, Keith Ray, Ron Shoesmith, Malcolm Thurlby, Jim and Muriel Tonkin and David Whitehead.

About the Author

Malcolm Mason lives in Herefordshire. He is chair of the Eardisley History Group and edited *Eardisley: Its Houses and Their Residents* in 2005, and last year edited their latest book on the village's early history. Between 2007 and 2009 he was the project officer for the 'Reminiscences of Leominster Life' project based at Leominster Museum. Volunteers collected oral histories from the town's older residents, which were published by Logaston Press as *Leominster in Living Memory* in 2010. He has also written books on the town for Amberley Publishing in the *Through Time* and *History Tour* series.

About the Archive

Many of the images in this volume come from the Historic England Archive, which holds over 12 million photographs, drawings, plans and documents covering England's archaeology, architecture, social and local history.

The photographic collections include prints from the earliest days of photography to today's high-resolution digital images. Subjects range from Neolithic flint mines and medieval churches to art deco cinemas and 1980s shopping centres. The collection is a vivid record both of buildings that are still part of everyday life – places of work, leisure and worship – and those lost long ago, surviving only in fragile prints or glass-plate negatives.

Six million aerial photographs offer a unique and fascinating view of the transformation of England's towns, cities, coast and countryside from 1919 onwards. Highlights include the pioneering photography of Aerofilms, and the comprehensive survey of England captured by the RAF after the Second World War.

Plans, drawings and reports provide further context and reconstruction artworks bring archaeological sites and historic buildings to life.

The collections are housed in a purpose-built environmentally controlled store in Swindon, which provides the best conditions to preserve archive items for future generations to enjoy. You can search our catalogue online, see and buy copies of our images, as well as visiting our public search room by appointment.

Find out more about us at HistoricEngland.org.uk/Photos
email: archive@historicengland.org.uk
tel.: 01793 414600

The Historic England offices and archive store in Swindon from the air, 2007.